the Art of Brush Lettering

A STROKE-BY-STROKE GUIDE TO THE PRACTICE &
TECHNIQUES OF CREATIVE LETTERING & CALLIGRAPHY

KELLY KLAPSTEIN

QUARRY

Brimming with creative inspiration, how-to projects, and useful information to enrich your everyday life, Quarto Knows is a favorite destination for those pursuing their interests and passions. Visit our site and dig deeper with our books into your area of interest: Quarto Creates, Quarto Cooks, Quarto Homes, Quarto Lives, Quarto Drives, Quarto Explores, Quarto Gifts, or Quarto Kids.

© 2018 Quarto Publishing Group USA Inc.
Text © 2018 Kelly Klapstein
Photography © 2018 Quarto Publishing Group USA Inc.

First Published in 2018 by Quarry Books, an imprint of The Quarto Group,
100 Cummings Center, Suite 265-D, Beverly, MA 01915, USA.
T (978) 282-9590 F (978) 283-2742 QuartoKnows.com

Quarry Books titles are also available at discount for retail, wholesale, promotional, and bulk purchase. For details, contact the Special Sales Manager by email at specialsales@quarto.com or by mail at The Quarto Group, Attn: Special Sales Manager, 401 Second Avenue North, Suite 310, Minneapolis, MN 55401, USA.

10 9 8 7 6 5 4

ISBN: 978-1-63159-355-0

Digital edition published in 2018

Library of Congress Cataloging-in-Publication Data available

Cover and Book Design: Megan Jones Design
Photography: Kelly Klapstein, except for photos of author on pages 6, 24, 159 by Madeline Ludlage Photography

Printed in China

For Elmar, Matthew, Serena, and Mila

jolie

jol

jo

olife

joli

joli

Contents

INTRODUCTION

Pen. Ink. Paper. Sitting quietly, one enters a sacred space and the rest of the world falls away. As the pen touches the paper and ink starts to flow, the harmony of black and white transforms into a ballet of beautiful letter strokes. A serene scene unfolds, with lovely loops and gentle curves, yet there is also exciting drama in the bold contrast of black characters on a white backdrop. The rhythmic movement of the brush pen across the paper is both enchanting and calming, and a quiet, profound joy arises upon drawing a single, beautiful letter.

Join me on this peaceful journey as I guide you stroke by stroke in the art of lovely brush letters. Along the way, you will learn the mindful practice of writing while staying focused and present. Tracing the letterforms on my practice guides will lead you on the path toward feeling calm and centered.

As the letters flow from your pen, you will experience a quiet tranquility, where stillness envelopes you, and your lettering practice will transform from a mundane drill into a daily meditation. Your peace of mind is only a brushstroke away.

Ever since I was a young child, I was writing fantastical stories on reams of looseleaf paper from school. A ballpoint pen was my constant companion, but calligraphy or artful lettering had never even crossed my mind. Eventually, the computer and printer replaced my written handiwork, and I concocted my works of fiction using a keyboard. I started and stopped writing a handful of novels, always dreaming of being published someday.

After teaching high school English and English as a Second Language (ESL) for ten years, I decided to stay at home to raise my children. Their teenage years arrived quickly, and I was feeling restless, so I began writing for several publications, eventually finding a home with *Creative Scrapbooker* magazine. The magazine became a community of close, supportive friends, sharing a love of all things handmade. I decided to become a freelance instructor and began teaching paper crafting classes, like scrapbooking and card making.

Then, in the summer of 2015, I found myself in the middle of an ongoing family health crisis along with experiencing the death of my father. I began to spend more time online enjoying social media as an outlet and escape from the *real* world. Instagram quickly became my favorite, and I started taking beautiful photos of nature, sharing them, and enjoying all the artistic galleries.

Photo by Madeline Ludlage Photography

One day, I came across a video of a brush pen drawing beautiful letters. I was mesmerized. I knew I had these pens sitting untouched in my studio. That day, I opened my box of Tombow brush pens and began my journey into brush lettering. I came across a thirty-day Instagram alphabet challenge and committed to participating.

This new community of hand lettering artists were so supportive and encouraging that I continued to practice diligently every single day, long after the initial challenge had ended. For months, I did daily drills, letters and words, and then there was that moment of muscle memory that happened. It was an incredible feeling when all the hours of practice paid off. It was as if my hand simply remembered the letterforms automatically: All the pressure and release points came naturally, the transitions happened seamlessly, and my curves and loops were elegant and flowing. I seemed to have entered the highest level of *calm zone* with the letter strokes flowing effortlessly out of my pens.

During this whole process, the teacher inside of me was thinking of ways to help people learn this beautiful art form and share my newfound love of brush lettering. Soon, I developed a set of basic practice worksheets that were essentially tracing guides to build muscle memory. I took this first set of worksheets and taught a small workshop and could see right away that the sheets were the best way to learn. In fact, the act of tracing the letters was calming and relaxing in and of itself, just like drawing them freehand, and everyone in the class expressed how they enjoyed the feeling of slowing down and being mindful of every stroke they drew.

Shortly after, I began making simple lettering videos for Instagram, either words or letters and phrases that I found meaningful. The response was overwhelming, and suddenly, my Instagram feed had hundreds of thousands of people following and viewing the videos. They wanted to learn, and they also wanted to relax. Apparently, my fluid letterforms were mesmerizing, and I began receiving so many messages from people all over the world, thanking me for helping them to feel calm and bringing them a few moments of peace.

I have discovered that brush lettering is more than writing pretty words. It is an artistic, mindful practice that brings me a deep sense of joy, fulfillment, and calm. I hope that this book helps you develop a meditative daily practice of peaceful, beautiful letters.

1

The Meditative Art of Drawing Letters

The art of brush lettering is more than just writing with a pen on paper. It's a mindful practice that relaxes and calms. When you're immersed in drawing a stroke, forming a lettering, and mastering the technique, you become present in that moment. Your mind and body are engaged and nothing else matters. The practice of calligraphy has the power to create calm in our lives and bring clarity to our thoughts for the entire day.

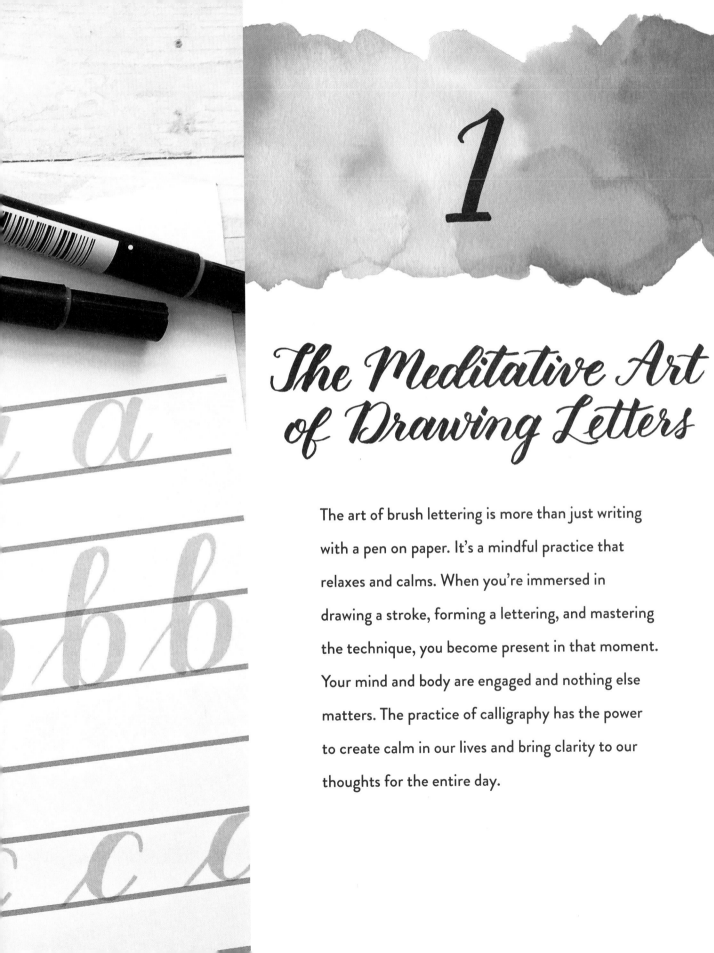

WHAT IS BRUSH LETTERING?

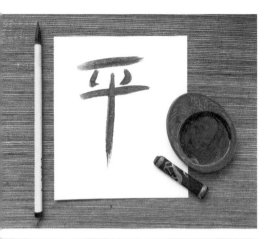

The beauty of artful lettering has deep roots in Asia and the Middle East, where painting scripts has been an integral part of those cultures for centuries. Using a variety of brush tools to create different strokes and combining them to form characters expresses and identifies the artist's personality and style. The method involves pressure and release on the brush to make thick and thin strokes.

Traditionally, black ink and paint are used on special paper, and the artistry of the brushstrokes conveys emotion and energy, transforming the characters from mundane letters and words into meaningful drawings and symbols (top left).

This art of brush letters sees more precision in the discipline of traditional calligraphy, which involves a dip pen or pointed pen holder, metal nib, and liquid ink (bottom left). The metal nib replaces the brush tip for finer lines and greater control, but with the same pressure and release technique. Although the same method or skill is relevant, there is more finesse when drawing the letterforms on a smaller scale.

Actually, contemporary brush lettering draws from both skill sets of paint brush and calligraphy pen nib, with the brush pen arising as a modern tool and approach to an ancient art. With a fine-tipped brush pen, one can almost replicate the pointed pen calligraphy styles, such as Copperplate and modern calligraphy (opposite).

The larger brush pens mimic the *real* paintbrush style of lettering. With the brush tips being larger, in general, the size of the letterforms follow suit, with greater contrast between the much thicker downstrokes and the thin upstrokes than are achieved with a small-tip brush pen.

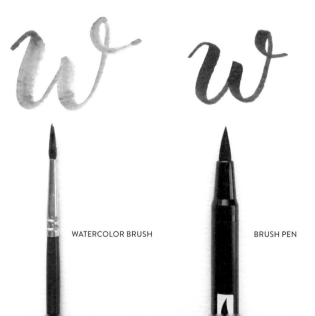

WATERCOLOR BRUSH BRUSH PEN

Essentially, the brush pen has gained popularity because it's considered *user friendly* in terms of simply putting pen to paper, without the added challenges of dipping into ink or paint and then managing the consistent flow of liquid onto paper. There's no time spent caring for the tools, like cleaning brushes, storing paints properly, or preparing nibs and then washing and drying them with care. With a brush pen, there's practically no maintenance, other than replacing the cap tightly so the ink doesn't dry out of the tip. In a world that's obsessed with convenience, the brush pen is bringing the art form of lettering and calligraphy into the hands of the young and the old, with minimal cost. With the added convenience of purchasing brush pens in art supply stores or online, the art of brush lettering is accessible without the time commitment of shopping for expensive supplies.

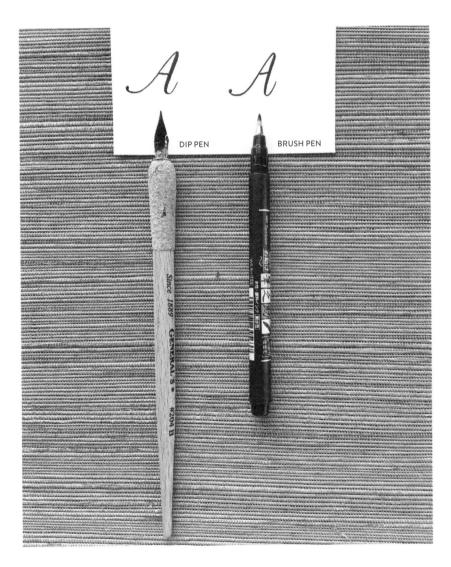

DIP PEN BRUSH PEN

Copperplate calligraphy style.

Brush Lettering Is Not Handwriting

Even though the tool is a pen, brush lettering is not handwriting. Better known as script or cursive, handwriting with a bullet tip or ballpoint pen has a similar structure to brush lettering, but the skill and technique involved are quite different. While cursive handwriting is composed of fluid letters that are connected to make words without lifting the pen from the paper, there are no pressure changes or considerations for separate strokes.

In contrast, brush lettering involves pressure, release, starting, lifting, and pausing in terms of drawing the basic strokes and then fitting them together like pieces of a puzzle to form letters and words. That said, I do appreciate cursive handwriting as its own art form, in danger of being lost in modern English-speaking society because of technology, computers, fonts, and printers. In fact, handwriting in schools is becoming uncommon and is often removed from the curriculum. Although there are those who are relieved about this trend, I believe we're losing a significant art of expression that most other cultures are preserving. It's a sad day, in my opinion, when a younger person can't read my brush lettering or handwriting and asks, "What does this say?" Perhaps the resurgence of calligraphy and hand lettering will ignite the younger generation to learn script and prompt the older generation to demand its return to the elementary school classrooms.

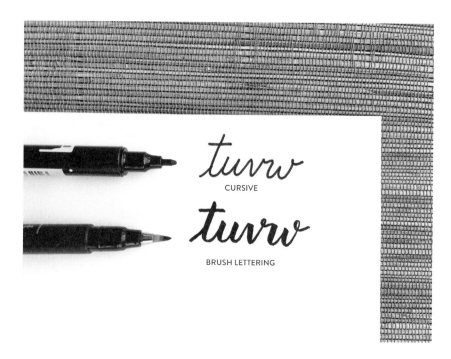

CURSIVE

BRUSH LETTERING

A MINDFUL & MEDITATIVE PRACTICE

The common thread that binds all these art forms of written expression is mindfulness. This is where the focus and deliberate execution of drawing the letters elevates both the words and the scribe, imbuing the script with a serene elegance and captivating the reader with its thoughtful lines.

So many people have asked to see my *real* handwriting, and one of the most popular questions I am asked is, "Is your daily writing messy?" The answer is "Yes!" No, I don't write shopping lists with brush pens and use calligraphy for phone messages. The difference is mindfulness. I scribble down notes and lists all the time, but my brush lettering practice is different. When I sit down with the intention to draw letterforms, I concentrate on the movement of my pen and the ink flowing onto the paper, forming the shapes, connecting them, and thinking about my pressure and release points and the transitions. Then, I pause and review my letters, using my *critical eye* to examine what went well and where I want to improve. How do I accomplish this? I cultivate my practice in a calm environment.

Being mindful with brush lettering isn't about multitasking. It's the exact opposite. There are times when we should not be multitasking, and although taking on a dozen projects and working on them at the same time can be admirable and even preferable in certain situations, drawing letterforms is best done as a singular goal, with focus and presence.

Is it possible to create quiet time for ourselves and sit still for a period without distractions? I believe it is. Cultivating a mindful practice takes commitment. Finding a calm space to draw letters can seem impossible when the kids are running around and the cell phone notifications are popping up. This means turning off the TV or Netflix or music, shutting down the laptop, and putting the cell phone on silent. It can be done. Try it. You don't have to carve out hours of quiet time, just start with 15 minutes a day like this. Your body and mind will begin to respond and soon expect, even crave, this time of solitude where you, your pen, and some paper spend time together in a sacred space. Essentially, you're training your entire body to practice brush lettering, and this is a significant concept to understand. It's your whole being drawing those strokes, not just the pen, or your hand and arm. It's all of you that's present and centered and focused. This is what makes all the difference. This is when your letters become beautiful.

The Healing Path of Drawing Letters

When I was first learning brush lettering, it was summertime in Canada. Our summers are short and not terribly hot, but it was mid-July and we were having a heat wave. So, in the mornings, I would wake up early, walk our dog, and then sit outside on our back deck with a cup of tea and draw letters. It was a stressful time in my life, with family issues and health problems, aging parents, and so on. We all have stressful, busy lives. That is a given. This solitude combined with brush lettering was healing for me. The sun was shining, the birds were singing—clichéd, but true—and the beautiful strokes began to flow from my pens. This became my ritual that summer, a daily meditation where time stopped and I was lost in the graceful lines and curves of the letters. My love affair had begun, and my daily morning meditation of practice turned into a calming ritual that centered me throughout the day.

The path to beautiful letters and cultivating a calming practice can be frustrating if one is impatient. Retraining the mind and body to stop, focus, and slow down is an incredible act of strength, but the rewards are many. This is a long-term goal, not an overnight accomplishment. Like any skill or art, brush lettering requires dedicated, repetitive practice, meaning hundreds of brushstrokes and countless hours of drills. At the same time, it isn't meant to be a chore or a task at the bottom of a to-do list. Even when I was learning at the very beginning, I felt great joy just putting pen to paper and referred to my practice as *playing*. After all, every art form requires a playful approach, an openness and curiosity that will lead to an expression of your true self.

Nothing Is Perfect

Although many people have commented that my brushstrokes are "perfect," that term makes me uneasy. Perfection is an illusion. You're not trying to create an exact computer font. Be particularly gentle with yourself when you're learning and celebrate improvements, no matter how insignificant they may seem, because sometimes the changes are subtle, yet they're still important. Developing your own style of brush lettering is a fulfilling process, a journey toward expressing yourself artfully and mindfully.

How This Book Will Help You Learn Brush Lettering

The approach of this book is to provide instruction and structure, and also to encourage you to explore your own style and accept your natural inclinations of drawing letters. The best approach is to proceed in order from chapter 1 to chapter 8, using the tracing guides at the back of the book when prompted. First, I explain the supplies required and demonstrate the proper technique of grip and angle of the pen on paper. We begin by learning and repetitively tracing the basic strokes, and then advancing to letters to build up muscle memory. Starting with the simple forms, such as the letters *i* and *t*, we progress to master the more challenging curvy letters with ovals, such as *b* and *d*. Then, leaving the tracing practice sheets behind, you will begin your adventure of creating your own lettering style. In chapter 6, you'll learn the technique of *faux calligraphy* and freestyle brush lettering with an easy set of guidelines, and chapter 7 highlights some ways to make your letters appear dimensional.

Tracing guides for both lowercase and uppercase alphabets designed for both small and large brush pens, plus numbers, are found at the back of the book, with perforations for you to remove them and lay them out flat on a table for practice. The paper used for this book and tracing sheets is suitable for brush pens. The smooth surface of this quality of book paper won't damage or fray your brush tips like rougher printer papers; however, it's inevitable that your first brush pens will break down more quickly because of overuse and misuse, and that's totally normal. It just gives you an excuse to buy more brush pens!

2

Mind & Body Pen & Paper

Brush lettering is a whole body experience. In this chapter, you learn how posture, pen grip, and paper angle are important elements to consider when learning calligraphy. Understanding your brush pens and the differences among types and brands will help you decide which pen is best for you. Paying attention to your body position, along with choosing appropriate pens and paper, will result in relaxing and enjoyable practice sessions.

MIND & BODY

In every art, the tools of the artist are the essential methods of creation. We often don't think about how the mind and body are just as important creative instruments as the pens and paper. Beautiful brushstrokes do not arise from holding the perfect pen in your hand. Bringing a calm heart and mind to the table will lead to drawing gracefully and fluidly.

How does art become an authentic expression of the artist's soul and imagination? With brush lettering, as with other art forms, the artist's entire being has a profound impact on the drawn strokes, letters, and words. When placing the brush tip to paper, the mind and body must be prepared and disciplined because they are deeply connected to the strokes of ink. Even though letters and words will still convey energy in a multitude of ways—calm, excited, joyful, pensive—your brushstrokes will be executed with confidence and skill when you understand how your mind and body are intimately connected with the ink on the paper.

Herein lies the challenge: How does one establish a peaceful practice of brush lettering? For beginners, there are a number of ways to cultivate calm:

1. SIT: Find a quiet spot, with a table and chair, where you can retreat every day for at least 20 minutes.

2. QUIET: Turn off phones, music, and the TV. Unplug. This can be scary for some people, but try your best to reduce noise.

3. EMPTY: Place your paper in front of you. Stare at the blank white canvas, uncluttered. Think of it as your mind . . . empty, pure, and restful.

4. BREATHE: Pick up your brush pen and hold it loosely, arm resting in position on the table. Close your eyes and breathe deeply three or four times. Slowly inhale, counting to three. Then slowly exhale, counting to three.

5. OPEN: Open your eyes and begin with basic drills: thick downstrokes first and then thin upstrokes.

When I was learning brush lettering, I unknowingly established a calming practice by sitting outside on my deck in the mornings before anyone else was awake in the house. Many people start with meditation early in the day, to set the tone for the hours ahead in much the same way. Stroke by stroke, I acquired a peaceful state of mind, my body relaxed, and stress fell away. After making the initial effort of spending quiet time alone with

my brush lettering during the first couple of months, the same sense of calm gradually enveloped my body and mind whenever and wherever I sat down with pen and paper. Now, I can be working on my computer, anxious about a deadline, and then pause to pick up a brush pen and paper nearby (which I always keep on hand wherever I am) and simply write a few words or phrases, play with some letter styles, and feel calmer, more focused, and balanced again. Unconsciously, in my early days of practicing and learning, I had been training my body to respond with calm and joy.

Is my life stress-free? Not at all. But I somehow feel more in control and settled by having a daily practice of lettering. Whether you're shuttling your kids from soccer games to music lessons, or preparing a deal-breaking presentation for the office, or studying for a final exam, learning to calm yourself with meditative, mindful lettering will reenergize you and help you navigate those stressful moments more easily.

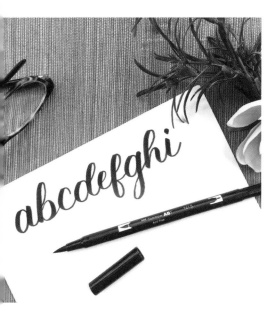

Fatigue & Well-Being

Most of my introductory brush lettering workshops run about 3 to 4 hours. After the first couple of hours, most people express that they're feeling some discomfort, and their hands are tired. I see them stop and shake out their hands or stretch out their fingers. Others also say their hands or fingers are getting cramps, and some even comment on experiencing soreness in their necks, shoulders, and backs. I always incorporate some simple stretching exercises that were recommended by a physiotherapist, which I share with you here, and reminders to listen to your body while practicing. Let's discuss why this happens and how to prevent fatigue and strain while brush lettering.

Caring for Your Fingers & Hands

There are a couple of reasons that your hand and/or fingers will get cramped. Many beginners are nervous about learning or feel uncertain about their skills, so they tense up and hold their brush pens in a death grip. During a workshop, I continually remind everyone to loosen up. In fact, when I hold my pen, I have the lightest, most relaxed grip possible. This means your knuckles shouldn't be bent inwards and your fingertips shouldn't be white from pressing down hard on the barrel.

If you're unable to monitor your own grip, then set a timer that beeps every 5 minutes or so as a reminder to loosen your grip. The more relaxed your grip is, the more fluid your letters will be.

The more obvious reason for feeling fatigue in your hand is quite simply overtiring muscles that you haven't been using very often. Surprisingly, holding your hand in one position and performing repetitive movements requires muscle strength and endurance that requires training, just as a person who leisurely walks his dog once in a while can't suddenly put on track shoes and expect to run a marathon. Modern technology in the form of computers and keyboards have taken the place of pen and paper, even in classrooms where tablets are more common for notetaking than traditional handwriting.

Because you're familiarizing yourself with writing for longer periods of time with intent and purpose, you'll need to build up your hand strength gradually by starting with shorter practice times. After a week or so of 20 minutes a day, stretch it out to 30 minutes a day for the second week, and so on. Keeping under an hour in general at one sitting is a good schedule, but you'll become in tune with your body to ascertain whether you can sit and practice for lengthier intervals.

Here are some simple stretches for your hands to release tension. Hold each pose for approximately 5 seconds.

Neck & Shoulders

Sitting at a table or desk for extended periods while looking down will have an impact on your physical well-being, particularly your neck and shoulders. My neck and shoulders are where I carry most of my tension, so I've noticed a dramatic change in the soreness and stiffness of the muscles and joints in this area. Here are a number of common, simple stretches for your neck and shoulders that will be helpful before, during, and after a brush lettering practice session. Hold each stretch for about 5 seconds.

Head rotation, left and right.

Chin down, chin up.

Head tilt, left and right.

Shoulder hug.

Shoulder raise.

Shoulder drop.

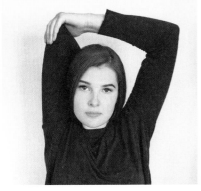

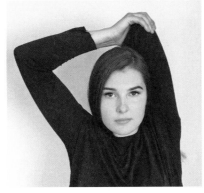

Elbows up, left and right.

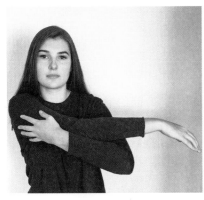

Arms across chest, left and right.

Side stretches, left and right.

Posture & Sitting

Sitting comfortably with proper posture at a table or desk is an incredibly important consideration because you are literally lettering with your whole body. If you're crouched on the floor or lying in bed, you'll develop poor practice habits along with soreness and strain. When your body is feeling at ease and stable, this will translate into your letterforms and add to the calming experience of practice.

With a standard chair and table height, sit with your feet planted and grounded in a relaxed position. Both arms are resting on the table, from elbows to hands. You are leaning slightly forward without hunching and your head is tilted downward to look at the paper. Believe it or not, core strength is a valuable asset when brush lettering to keep your spine straight and prevent your shoulders from slumping. Without strong abdominal muscles, your back might become sore and you will probably end up slouching over your table. Engaging your core while lettering will lead to better posture and longer practice sessions. If your abdominal strength is weak, shorten your sitting periods to protect your back.

Are you restricted to sitting at a table or desk forever? Not at all. This is the starting point for beginners to develop ideal practice habits. After you become proficient, you can take your brush pens and pads anywhere and feel calm and relaxed wherever you go. The wonderful thing about this art is its portability. Put a few pens and a pad of paper in your purse, briefcase, backpack, or laptop satchel and your meditative state of mind is always within reach (and at hand).

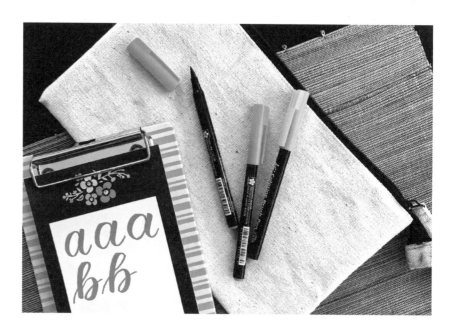

PEN & PAPER

The essential tools of the lettering artist consist of a sweet, simple list of two items: pen and paper. The minimal effort required to obtain these items is a welcome relief from other art forms and crafts that involve an overwhelming number of products that can be challenging to find. Another benefit of brush lettering is its simplicity: applying pen to paper. Let's take a look at brush pens, paper choices, and the best options for beginners.

Brush Pen Tips

There are basically two types of brush pens: solid tips and brush strands. The large brush tips are usually composed of a stiff "felt" material while the small brush pens have a flexible nylon plastic tip.

 The tips with brush strands are softer and can create a greater contrast of thick and thin strokes; however, more skill is required to use them. That's why I recommend solid-tip brush pens for beginners who are just learning the skill.

 Both types of brush tips are flexible and have enough elasticity to handle applied pressure and then bounce back into shape. That's the key difference between a good brush pen and a poor one: elasticity and flexibility. Many brush pens can be frustrating to use because the tip doesn't bounce back into a straight point, but remains slightly bent. The brush pens I show and share in this book are ones I've used and recommend, but there are many others I haven't tried, so it's a matter of trial and error to find a new brush pen that works well and that you enjoy using.

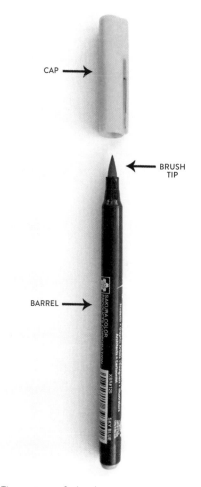

CAP

BRUSH TIP

BARREL

The anatomy of a brush pen.

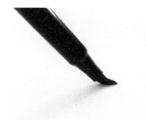
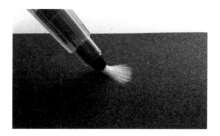
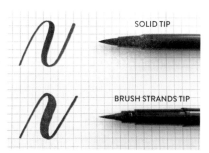

SOLID TIP

BRUSH STRANDS TIP

Two types of brush pens—solid tip and strand tip—and the marks they make.

Solid-Tip Sizes

I simply categorize brush pens with solid tips as small and large, depending on the size of the brush tip, not the actual physical size of the pen. Note that there are variations in size, especially among large brush tips, with some tips being thicker than others. Small brush pens have tiny, flexible nylon tips that create much thinner strokes, both up and down. This book includes instructions and tracing guides for both small and large brush pens.

Regardless of the size of the brush tip, the technique for using it is the same: heavy pressure for thick downstrokes and light pressure for thin upstrokes. The skill lies in transitioning the pressure from thick to thin and vice versa, which is covered in chapter 3 (see page 32).

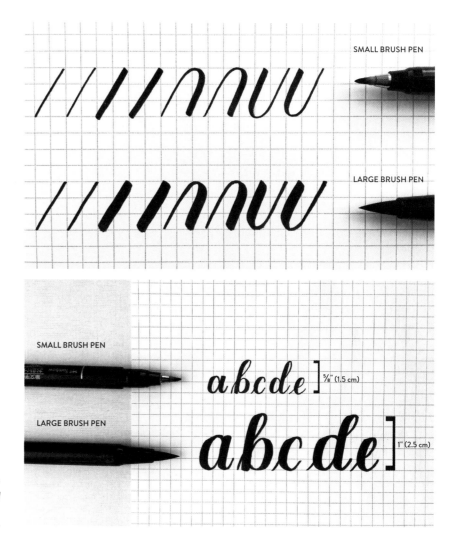

Although both small and large brush tips can be used to create a wide range of letter sizes, the smaller tip can write much smaller letters. The larger the brush tip, the more challenging it is to navigate the curves and transitions cleanly if you're trying to write smaller letters.

The instruction and tracing guides in this book are for both sizes of brush pens, and there's a huge variety of brands on the market. Even with the large brush tips, there are variations in size, with some tips being thicker than others. Their availability varies in different countries, but in general, it seems that brush pens can be found in art supply and craft stores around the world. Actually, they're also used for illustrations as well as lettering and calligraphy.

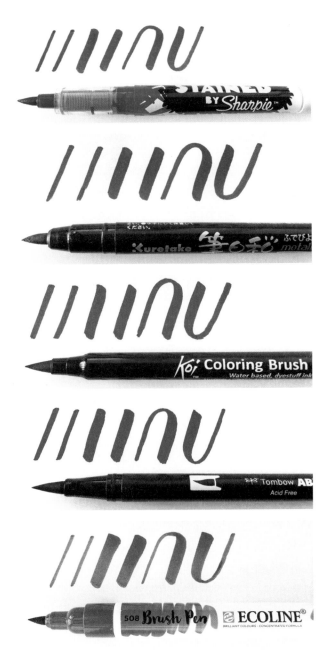

Just a few brands of brush pens—Sharpie, Kuretake, Sakura, Tombow, and Ecoline—and the marks they make.

Caring for Brush Pens

The number one rule about caring for your brush pens is to always replace the cap tightly. Try not to leave your cap off even for a few minutes. Become accustomed to understanding how the cap fits your brush pen. Does it click to snap into place for airtight closure? Some caps do and some don't. Treat your pens well, and they'll treat you well.

The most common question about storage is "Should I store my brush pens vertically or horizontally?" For lots of brands, the answer is that it doesn't matter, but some manufacturers recommend horizontal storage because the ink needs to have contact with the interior end component of the brush tip fibers so they don't dry out. However, many brush pens have pressurized barrels and can be stored in any position. Although you should check the manufacturer's instructions, I keep it simple and store most of my pens horizontally, lying flat in pencil cases, bins, or boxes. Some brush pen sets even come with storage cases or containers, which are an advantage and highly useful. Wherever you store them, keep the pens away from extreme heat and cold; room temperature is always a good idea.

What Kind of Paper Should I Use?

There is one word above all when used to describe paper for brush lettering: smooth. The tips of the brush pens can endure a lot of pressure, but they can't withstand friction. If you write on regular copy or printer paper, the friction of the rough paper against the tip will break it down. Instead of a fine, sharp point, the end will appear to be frayed and your thin upstrokes will look messy and jagged.

Even with smooth paper, the tips eventually break down, but they will last much, much longer. Regular paper probably doesn't seem rough to you, but once you touch nice, smooth paper, you'll be able to tell the difference easily. The other advantage of smooth paper is how it allows your brush tip to glide and flow effortlessly. The less friction, the better!

Here's a look at a few options for smooth paper.

1. LASER PRINT PAPER: One of the most common and cost-effective paper choices is heavyweight, high-quality laser printer paper. Many calligraphers and lettering artists use this type of paper. The brand I use is HP Premium LaserJet 32 pound because it's easily accessible and affordable, plus it comes in a 500-sheet pack that lasts forever and lessens the cost even more. It's not always the weight of the paper that indicates the smooth surface, but the two often correlate.

The printer paper is blank, so the best idea for practice is to find a digital grid paper to download by searching online and then printing it onto your laser paper. You don't need a laser printer. I use my regular inkjet printer with the laser print paper. Or, if you don't have a printer at all, go to your local copy store or ask a friend for a favor, and they can print out practice grids for you. There are lots of websites that offer free grid sheets, but here are links to the publisher's website (www.quartoknows.com/page/artofbrushlettering) and mine (www.kellycreates.ca) where you can download my free blank grid designs for printing.

2. TRACING PAPER: Tracing paper is a lightweight, translucent, smooth paper that's a good option for practicing brush lettering, especially if you're using tracing guide worksheets like the ones provided in this book. Place a sheet of tracing paper on top of your practice guides and secure with washi tape or removable tape. This keeps your tracing paper in place. Another strategy is to place your worksheet right inside your tracing paper pad since most tracing paper is sold in pads. Without worksheets, just place a lined or blank grid in between sheets in the pad as your guidelines.

3. SPECIALTY CALLIGRAPHY PAPER PADS: Art supply stores and specialty stationery shops carry paper that is used specifically for calligraphy. You can also search online for these pads, which offer a variety of grids and lines as practice guides. The search term is "calligraphy paper."

4. ART PAPER: Other suitable surfaces that work well with brush pens are marker paper pads, Bristol paper, and smooth cardstock found in art supply stores and craft stores. Because these options are specialty papers, the expense is greater. There are numerous brands of art paper on the market, and every calligrapher has their personal favorites, according to what's readily available where they live.

USING PAPER MINDFULLY

I'm not going to whitewash the facts: Brush lettering means using a lot of paper. There are a few considerations about the mindful use of paper. I treat every piece of paper like a prime piece of real estate, which means I practice over words and letters that are already written. There's little white space left when I'm finished. With heavy-weight laser jet paper, you can utilize both sides extensively. When the page is filled and filled again with lettering, I put it into the recycle bin. Surprisingly, I don't buy paper that often and feel at ease with my impact on the environment.

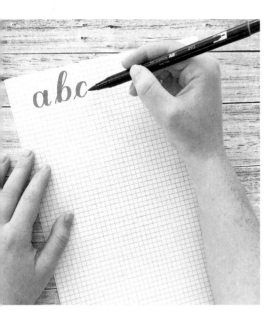

Placement of Paper & Angle of Pen

Now that we've sorted out everything you need to know about brush pens and paper, let's take a look at how you use them and prepare for practicing strokes or letters.

Sitting at the table, you have a single sheet of practice paper in front of you. As a beginner, having an absolutely flat surface, without bumps or ridges, is very helpful. Removing the tracing guides from this book so they lay flat on the table is the best practice method. If you have a single sheet of paper and not a book or pad for practice, then your hand will glide smoothly across to achieve fluid strokes and writing.

For right-handed people, the paper is usually angled or turned slightly to your left. Find your comfortable paper angle as you practice. The paper position in the photo (left) is most typical. Left-handed people will have the paper upright or turned in the opposite direction, slightly to the right.

The pen grip is a bit different than handwriting because you're gripping higher up on the barrel to achieve the correct angle of the brush tip on the paper.

There's a right way and a wrong way to apply pressure and write with your brush pen, and it's all about the angle of the tip when it touches the paper. This angle and grip never change while you're writing.

Holding the brush pen correctly at an angle is critical to achieving proper strokes. Do *not* hold your brush pen upright. When you hold the pen upright, at a more vertical angle, you're placing direct pressure on that fine tip, and doing so will break down the tip very quickly. If the pen is upright, you'll also have difficulty with transitions from thin to thick strokes.

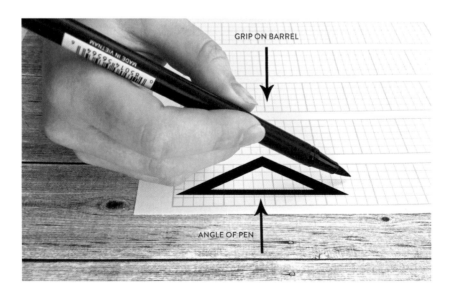

GRIP ON BARREL

ANGLE OF PEN

For beginners, I teach a 3-step process of learning how to grip the pen and achieve the correct angle for brushstroke success. Left-handed people would reverse the placements but can still use these same 3 steps.

1. Place your paper on the table in front of you, turned slightly to the left. Place your brush pen (parallel) along the top edge of the paper. Rest your arm along the right edge of your paper. Your pinky finger should be resting on the table and your thumb is facing upward **(fig. 1)**.

2. Without moving your writing hand, pick up the brush pen with your non-writing hand and place it into your writing hand **(fig. 2)**.

3. Slightly move the brush tip downward to touch the paper **(fig. 3)**. This is the grip and angle you'll maintain no matter what you're writing with your brush pen. Also note that you're holding the pen in a relaxed manner, without tension in your fingers. Your pinky finger is resting on the table at all times and serves as the stabilizer for your brush pen movements **(fig. 4)**.

Now that you understand the technique of positioning your paper and pen, we can learn the basic strokes and drills!

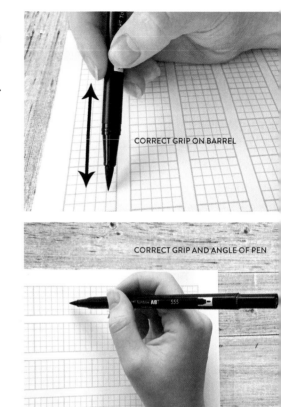

CORRECT GRIP ON BARREL

CORRECT GRIP AND ANGLE OF PEN

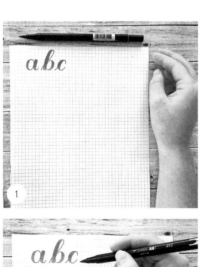

1

2

3

4

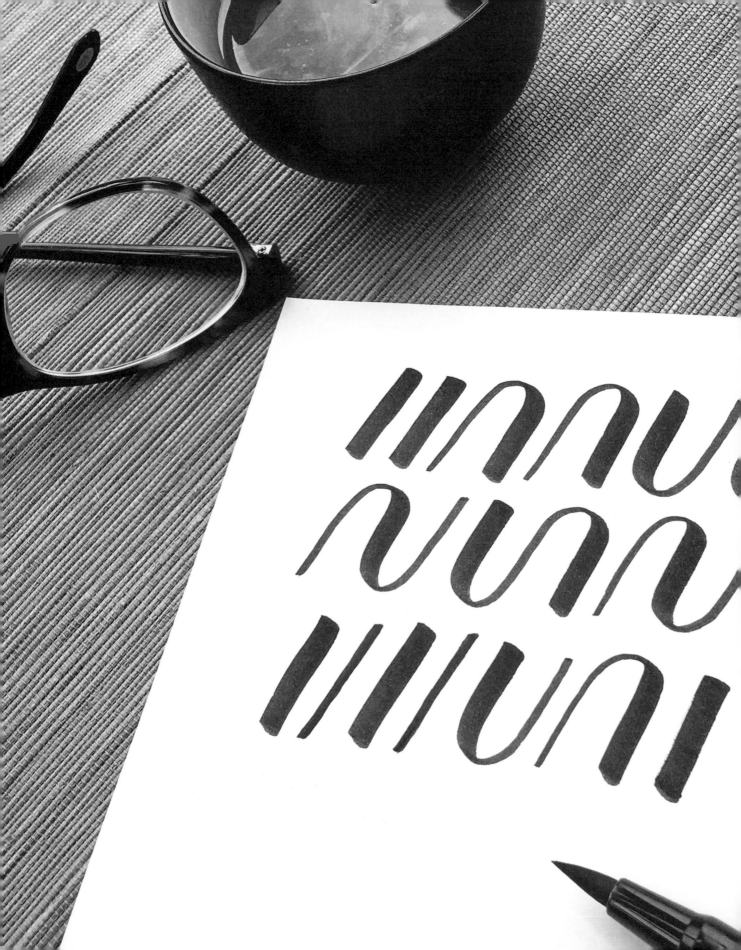

3

Basic Strokes & Drills

This chapter introduces you to the basic strokes that are the essential building blocks of drawing letters. By modifying the strokes a little, and also combining them, you'll be able to write the entire lowercase alphabet.

DRILLS FOR SKILLS

When I was learning the letters, I didn't have a guide, book, or teacher to explain where to begin, so I actually just started with the word *hi*, not knowing that there is a better way of building up skills. After some online searching while I was already working on the entire alphabet (in alphabetical order), I came across some calligraphy drills and saw letters being broken down into strokes. Then I realized how important the process of learning a particular order of strokes was. Most calligraphers profess to doing daily drills and emphasize their importance. I quickly came to understand how perfecting the strokes through repetitive drills results in very consistent letterforms and shapes.

So several months after my journey had begun, I started doing daily drills and practicing basic strokes. Whether you are an absolute beginner or a seasoned professional lettering artist or calligrapher, drills help warm up the hand and generate, develop, and maintain muscle memory.

What Is Muscle Memory?

What do a golfer's swing, a pitcher's knuckle-ball, and a basketball player's foul shot have in common? Muscle memory. And the same muscle memory plays a significant role in brush lettering. Consider yourself a lettering athlete!

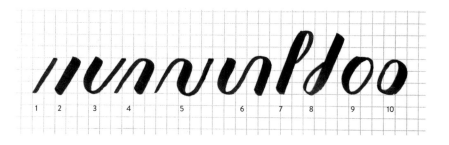

1 UPSTROKE		6 REVERSE COMPOUND CURVE	
2 DOWNSTROKE		7 ASCENDER LOOP	
3 UNDERTURN		8 DESCENDER LOOP	
4 OVERTURN		9 OVAL	
5 COMPOUND CURVE		10 REVERSE OVAL	

Believe it or not, learning brush lettering has something in common with sports involving fine motor skills, eye-hand coordination, and repetitive motions. They seem dissimilar but they actually have a significant commonality in terms of muscle memory. How do athletes successfully commit to the same motion and score points? By training their muscles to respond through repetitive practice. After countless hours on the court, on the baseball diamond, or on the tee box, the muscles of the body learn the *map* of exactly coordinated movements and eventually perform them responsively over and over again.

To achieve consistent strokes when learning brush lettering, muscle memory comes into play. For example, with muscle memory at work, all your ovals will be the same, so this translates into consistent and harmonious letters that have oval shapes, like *a*, *b*, *c*, *d*, *e*, *g*, *o*, *p*, and *q*. In fact, the letters with ovals are the last letters to learn because they are the most challenging curves.

Where do you begin? We start with learning the strokes and basic drills in a specific order. These strokes are inspired by the Copperplate style of calligraphy, which has greatly influenced how I learned brush lettering. In fact, many people refer to brush lettering as brush *calligraphy* because the structure of the letterforms is similar, along with the execution.

The difference between my style of brush lettering and Copperplate calligraphy is a rounder structure of letters without a strict adherence to the angle of the forms. Copperplate has a 52- to 55-degree slant to the strokes. Although my drills, basic shapes, and letters are at an angle, they're a little more upright overall. If you can't maintain a similar angle of your freehand letters, then draw diagonal lines on your paper as guides. Some of you will enjoy the freedom of not adhering to strict angle guidelines; however, others will appreciate the visual cues that diagonal guidelines offer. Do you need to copy the angle of my strokes, drills, and letters exactly as presented in this book? Not at all. My viewpoint of brush lettering is quite liberal in that I believe every individual can experience joy and draw beautiful letterforms by following their own rhythm and angle, with my tracing guides teaching proper technique.

USE YOUR CRITICAL EYE

Included with every basic stroke will be instruction on how to use your *critical eye*, which is identified with the symbol above.

In order to improve your skills, you will need to be able to observe your letterforms and examine them in terms of structure. Although it is important to be patient with yourself and take your time developing your skills, it is invaluable to be able to *see* what you are doing right and discern what needs an adjustment. Unless you are in a brush lettering workshop with access to an instructor's advice, you will benefit greatly from learning how to critique your own work. We all have areas to improve no matter what skill level we are.

PRESSURE & RELEASE

1

2

3

We've spent our entire lives using pens and pencils that aren't flexible. So, when you begin using a brush pen, there's a period of "getting to know you" in terms of understanding how the tip flexes.

In fact, many beginners in my workshops feel hesitant to put pressure on that brush tip and push down. But that's what the pen is made for, and a good brush pen will bounce back into shape upon release of pressure. Have no fear! The brush tip can handle the pressure!

You'll find that the stiffness of solid felt brush tips varies from brand to brand. Sometimes, you'll have to push harder and apply more pressure to get a thicker downstroke. But every brush pen has its limits, and you'll learn that you can achieve a stroke of only a certain maximum thickness no matter how much pressure you apply.

Testing Pressure & Flexibility

Whenever I get a new brush pen, before I use it for lettering, I test the tip by pushing down to create a teardrop. By doing this, I learn about the pen's response to pressure, its stiffness, and its flexibility.

To test the brush tip of a new pen, follow these simple steps:

1. Holding the pen at the correct angle, lightly touch the very tip to the paper (fig. 1).

2. Without moving the pen at all, slowly apply pressure from the tip upward until the entire side of the tip is lying on the paper (fig. 2).

3. Then, lift straight up. Do this several times. You'll feel how far the tip will bend, which will help you when you're drawing letters (fig. 3).

Once you've pressure-tested the tip of a new pen, warm up with the drills in this chapter so you know the full extent of its flex and how it responds to pressure before using it for lettering.

You can apply these techniques to any other brush pen, but keep in mind that switching from felt-tip pens to softer pens with brush strands always requires more practice and control.

As you learned on pages 30–31, holding the brush pen correctly is essential when executing your strokes. Even when you're using the lightest pressure on upstrokes, you're using the *side* of the very tip of the brush. With this same angle, you can apply pressure without changing your grip or hand placement at all and draw a thick downstroke.

Let's take an in-depth look at basic strokes and drills in terms of pressure and release, beginning with simple upstrokes and downstrokes.

Simple Upstrokes & Downstrokes

Every letter is composed of upstrokes and downstrokes. Basically, you'll always be moving your pen up and down and then making a few small adjustments with some cross strokes with letters such as *r*, *s*, and *x*.

Every downstroke is thick, with full pressure applied; every upstroke is thin, with the lightest pressure possible.

Your first goal is to apply pressure with these two basic strokes so that one looks thick and the other looks thinner.

KEEP YOUR GRIP & PEN ANGLE CONSISTENT

Remember: Do *not* change your grip or angle when drawing brushstrokes. The only thing that changes is the pressure on the pen. Whether you're drawing an oval, an ascender loop, or a simple upstroke or downstroke, your grip and pen angle remain the same.

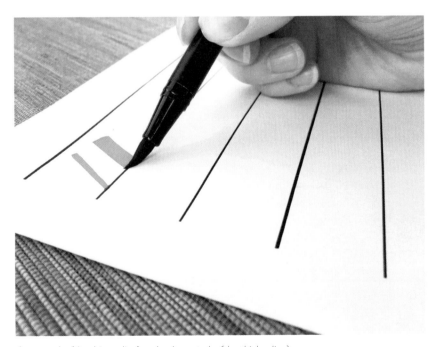

An upstroke (the thinner line) and a downstroke (the thicker line)

BASIC STROKES

To understand the terms I use when describing how to write the strokes and letters, here's a diagram that you'll find helpful:

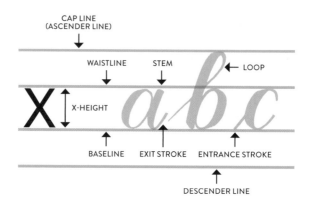

Basic Stroke 1: The Upstroke

Beginning at the baseline, touch the paper with the lightest pressure and move the pen upward at a diagonal toward the cap line, also called the ascender line, while maintaining the same light pressure. This diagonal line will vary when you leave behind the tracing sheets and draw freehand with your own natural inclination of angle.

Try not to worry about the upstrokes being hairlines, which are very thin strokes that most experts are able to achieve. And yes, the thin upstrokes are more difficult, with many beginners complaining about their shaky lines that are not thin enough. Be patient with your upstrokes. Eventually, your control and confidence will grow, and they will be thin and straight.

If your freehand upstrokes (without using a tracing guide) are shaky, there are a couple of methods to help you toward steady, even lines.

1. Place a dot at the top where your upstroke will end. Now, when you begin at your baseline, you have a target and can aim for this as you draw upward. Often, this visible endpoint helps make the upstroke more steady because you have a goal in sight and are more focused on that dot rather than being worried about getting there **(fig. 1)**.

2. Limit your wrist and instead generate movement from your shoulder and whole arm. Although my personal style involves more finger and wrist movement, directing strokes with whole arm and shoulder movement can create steadier lines. This is true especially when working with larger letters and flourishing **(fig. 2)**.

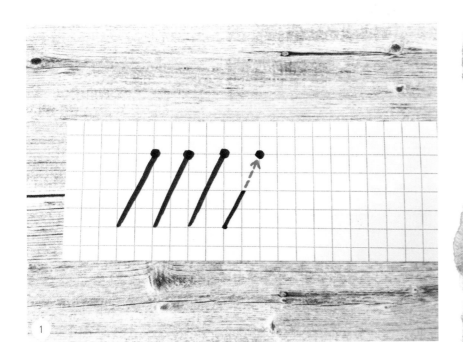

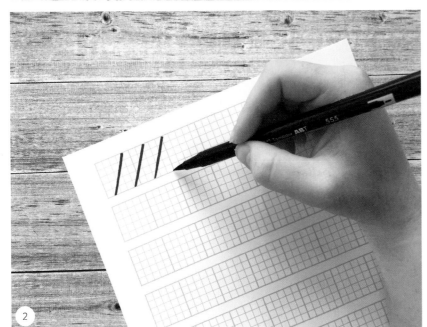

While drawing upstrokes freehand without tracing guides, keep your spacing consistent, so the distances between your upstrokes are equal. First, try this with grid paper to monitor the spacing and then experiment on blank paper. This will help in the future when you are writing letters to form words and judging the spatial distance between strokes.

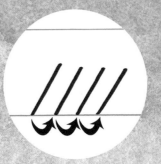

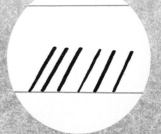

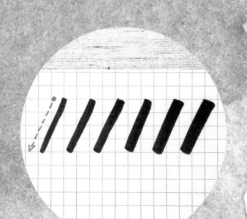

Basic Stroke 2: The Downstroke

Starting at or near the cap line, you'll be applying full pressure as soon as you touch the paper. Then pull the brush tip downward to the baseline at an angle.

Maintain the same pressure throughout the downstroke and lift at the bottom. Often, beginners say their upstrokes and downstrokes are almost the same. Sometimes, the issue is not pushing down and flexing that brush tip with full pressure. Since we're not used to pushing on a pen nib, this can be a difficult concept to wrap our heads (and hands) around. But if you've tested out the pressure on your pens beforehand, then you know you can push and get those thick downstrokes.

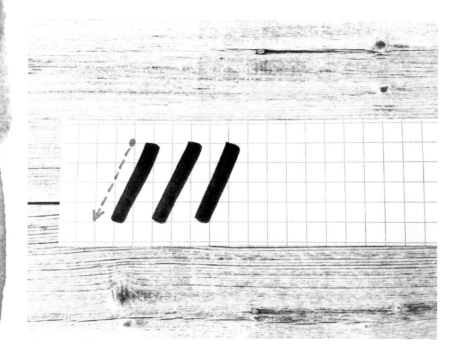

Basic Stroke 3: The Underturn

Now that you've become accustomed to the brush tip by applying heavy pressure or light pressure, let's move on to the next basic stroke, the underturn, which is a combination of the downstroke and upstroke.

The underturn appears the most often in the lowercase alphabet as compared to the other strokes. We find the underturn in the following letters as the basic foundation and structure and also as the exit stroke: *a, d, i, l, r, t, u, v,* and *w.*

The very first two letters you'll learn are essentially the underturn: the lowercase *i* and *t*. The *i* begins with full pressure at the waistline, while the *t* starts with full pressure at the cap line.

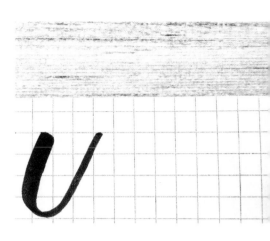

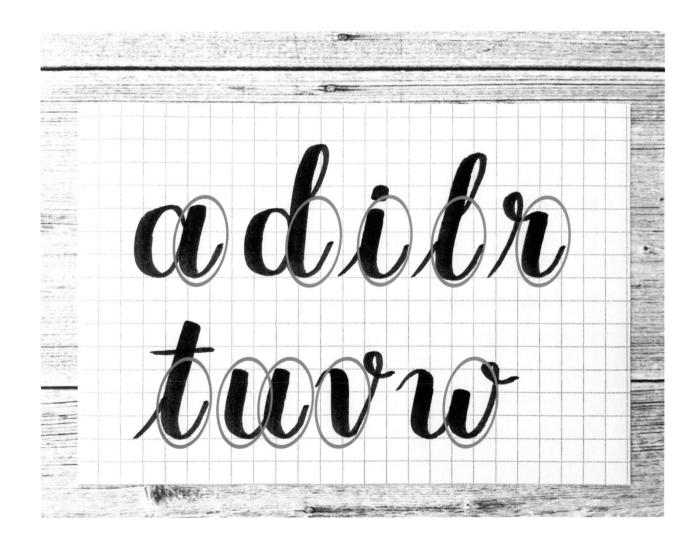

Releasing the pressure too late near the baseline results in a *heavy bottom*. Avoid this by lightening up the pressure earlier and slowing down during the transition (fig. 1).

The light upstrokes or exit strokes in the underturn are sometimes called *hairlines*. Your goal as a beginner is not to achieve a hairline, but simply to draw a thinner line than your downstroke. As long as you're creating a contrast of thick and thin parts of this underturn (and letters in general), then you're doing fine. In the future, with a great deal of practice, you'll be more adept at drawing really thin hairlines. For now, be content with fairly thin, even upstrokes (fig. 2).

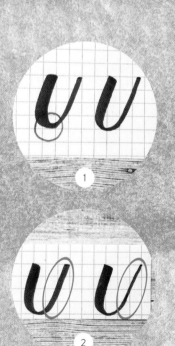

1. Begin with full pressure at your starting point and push your pen downward toward your baseline. You're moving the pen very slowly (fig. 1).

2. When you're approximately three-quarters of the way to the baseline, begin to gradually lighten up the pressure while continuing to move the pen downward with a slight curve to the right. At the point where you reach the baseline, you'll be at the lightest pressure, with only the tip of the brush touching the paper (fig. 2).

3. At the baseline, you'll now turn upward with the lightest pressure and exit the stroke (fig. 3).

4. Regardless of the angle of your underturns, keep the downstroke and upstroke parallel (fig. 4).

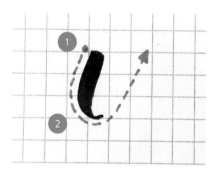

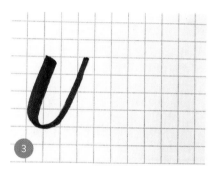

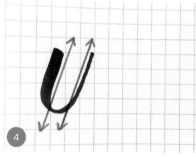

Key Technique: The Pressure Triangle

One term I use to describe a *transition* of pressure is *pressure triangle*. The subtle and gradual change of pressure results in a transition point, which I define more as an area or "triangle" rather than a single point. By focusing on creating this triangle when applying or releasing pressure, a better understanding of this skill will develop and your letterforms will improve.

Create a visible pressure triangle when you're releasing or applying pressure. Making smooth transitions is one of the more challenging skills to master.

Basic Stroke 4: The Overturn

Many beginners express that the overturn is easier than the underturn. The overturn is simply the opposite because you start at the baseline, draw a thin upstroke with a slight curve nearing the top, and then round downward with a descent of full pressure.

Check the inside or negative space of the interior of the overturn. Is the top of the hump nicely rounded? If not, then correct this by moving your brush tip more to the right at the waistline (or cap line) before you descend and apply the pressure more gradually.

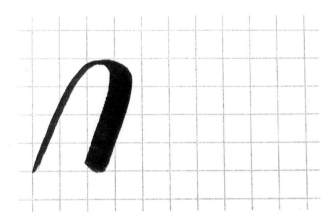

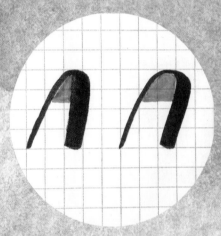

1. No matter how high you climb with that beginning upstroke, keep the line steady and even by anticipating reaching the top. By aiming for the top, your thin line should become less shaky because you're focused on a destination (fig. 1).

2. After touching the waistline or cap line, slowly curve downward to your right, applying pressure. Now your transition is the opposite of the underturn, but you're still creating a pressure triangle. Then, continue with full pressure right down to the baseline (fig. 2).

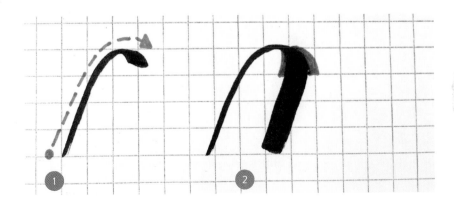

USE YOUR CRITICAL EYE 👁

Divide your compound curve into three strokes: upstroke, downstroke, upstroke. Use a ruler and draw diagonal lines with a pencil or pen through these three parts. Are they at the same angle?

Basic Stroke 5: The Compound Curve

The compound curve is a combination of the overturn and underturn. Essentially, if you overlapped the overturn and underturn by combining their thick downstrokes, then you have a compound curve: upstroke, downstroke, upstroke.

Compound curves can be found in the letters *h, m, n, u, v, w,* and *y.* My style involves modifying the entrance and exit so that they're a bit shorter.

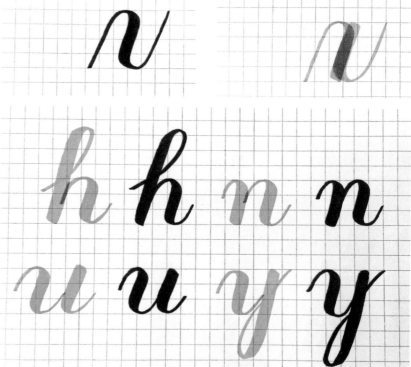

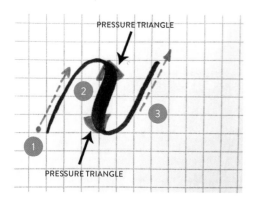

1. You begin the compound curve with a light upstroke as you first draw an overturn **(fig. 1)**. After curving at the top, you will create a thick downstroke with two pressure triangles.

2. There are now two transitions: the top of the overturn and the bottom of the underturn **(fig. 2)**. The skill lies in applying full pressure appropriately to that downstroke in the center. There's a short section in the middle of that downstroke that has full pressure.

3. After releasing pressure at the baseline, curve with lightest pressure and climb upward to finish the stroke **(fig. 3)**.

Basic Stroke 6: The Reverse Compound Curve

As its name suggests, the reverse compound curve is the opposite of a compound curve. It's essential for connecting letters when writing words in combinations such as *u–n* or *i–m* or *a–y*, along with many other variations.

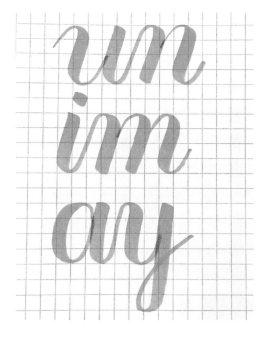

USE YOUR CRITICAL EYE

Turn your reverse compound curve upside down. Does it look exactly the same? Your goal is to achieve even spacing, transitions, and pressure.

1. The first half of the reverse compound curve is the underturn (**fig. 1**).

2. However, your thin upstroke becomes the entrance of the overturn (**fig. 2**).

3. Instead of stopping at the top, you curve to the right, transition by applying pressure, and then exit with a thick downstroke to the baseline to complete the stroke, like an overturn (**fig. 3**).

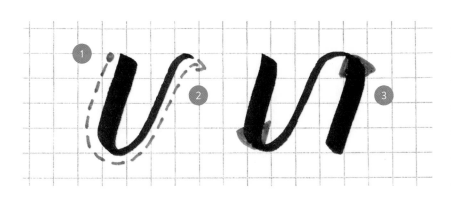

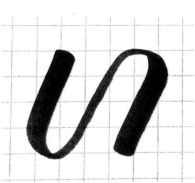

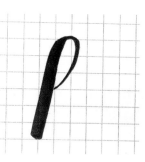
Color in the interior space of the loop. You should have a teardrop shape that has a smooth curve at the top.

Basic Stroke 7: The Ascender Loop

The ascender loop is found in the letters *b, d, f, h, k,* and *l*. The skill of this stroke lies in navigating the narrow curve at the top point with a transition in pressure.

1. First, let's look at the starting point and beginning light upstroke. In general, my starting point is at the waistline, and I draw a light upstroke on a slight diagonal to the right. In chapter 6, you'll learn how to modify this loop to alter the style of the letter. For now, we'll keep the loop narrow **(fig. 1)**.

2. As you approach the cap line, begin to curve to the left. Then, touch the cap line and start to descend, applying pressure. Here is your transition when you gradually achieve full pressure moving downward by creating your pressure triangle **(fig. 2)**.

3. At the baseline, you're at full pressure to complete the stroke **(fig. 3)**.

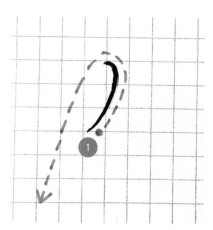

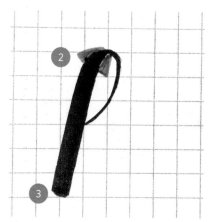

Basic Stroke 8: The Descender Loop

The descender loop is found in the letters *g, j, p, y,* and *z,* along with a modified reverse loop in the letters *f* and *q.*

How is the angle of your descender loop? To create a consistent shape in comparison with your ascender loop, draw them side by side to check. Also, try drawing an ascender loop and then, on top, draw a descender loop. Practice these together to develop similar, harmonious strokes.

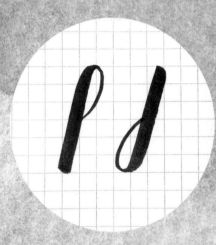

1. Starting at the waistline with full pressure, pull the brush tip downward **(fig. 1).**

2. When you near the descender line, lighten the pressure gradually to transition and create your pressure triangle, while curving slightly to the left. When you touch the descender line, you're at the lightest pressure **(fig. 2).**

3. Now you curve outward and upward to your left and then curve to your right. Continue in a right diagonal line to meet your descender line and close the loop at the baseline. The trickiest part of the descender loop is that transition to light pressure, creating a smooth, rounded bottom of the loop **(fig. 3).**

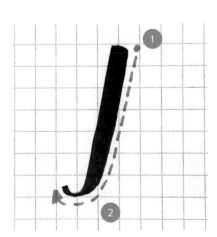

Slice your oval in half through the two transition points. Are the two halves symmetrical?

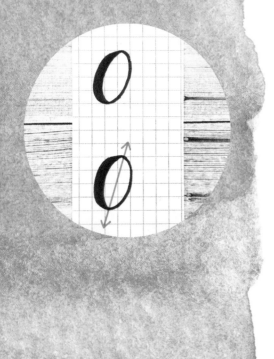

Basic Stroke 9: The Oval

The oval is found in ten letters of the lowercase alphabet: *a*, *b*, *c*, *d*, *e*, *g*, *o*, *p*, *q*, and *z*. Ironically, the first five letters of the alphabet are actually the last letters you should learn. The letters *b*, *p*, and *z* have a reverse oval.

abcde

The oval ranks highest in terms of difficulty level (along with the reverse oval); however, when you achieve that perfect oval, it's very rewarding. This stroke takes the longest to master because you're managing curves with two transitions and no straight lines.

1. As you can imagine, when drawing an oval, you're always curving slowly with your pen. My starting point is to the right of the top curve just below the waistline (**fig. 1**). I curve lightly upward to my left to reach the cap line and then begin my transition by applying pressure, curving downward to my left.

2. At the midpoint in the left curve, or *shade*, of the oval, I have full pressure (**fig. 2**). This full pressure is brief, and I continue to curve downward to my right, reaching the baseline with the lightest pressure.

3. After touching the baseline, I curve upward and draw the right side of my oval, aiming to meet with my starting point (**figs. 3 and 4**).

I call this start and end point joining a *meet-up*, and it's a skill that requires lots of practice and development of muscle memory. The benefit of starting and ending your oval in this way is that you can often cover up or camouflage a meet-up that doesn't go well with a stem, ascender, descender, and so on, just as in the example at left with the lowercase *a*.

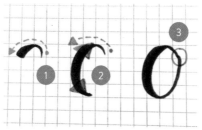

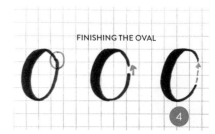

FINISHING THE OVAL

Basic Stroke 10: The Reverse Oval

The reverse oval is found in the letters *b* and *p* and is modified to write the lowercase *z*.

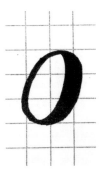

The reverse oval is a stroke that is the opposite of the oval. Creating a reverse of a regular oval doesn't always result in a mirror image and is very difficult to achieve. But the reverse oval can be very similar to the oval shape and look pleasing and harmonious nonetheless.

1. The starting point is the opposite of the oval starting point, and we begin with light pressure on the upper left side of the reverse oval, near the waistline (**fig. 1**).

2. Approach the cap line by curving to the right and then touch the cap line and begin applying pressure (**fig. 2**).

3. By the middle of the right shade, you have full pressure briefly and then release and transition as you curve downward toward the baseline (**fig. 3**).

4. At the baseline, you have light pressure and continue curving upward to your left and connecting your light upstroke to the starting point (**fig. 4**).

5. Your meet-up should be the same pressure as when you began the reverse oval (**fig. 5**).

These ten basic strokes are the foundation of your drills, which I recommend practicing daily.

With all the basic strokes covered, let's move on to the lowercase alphabet and see how these strokes evolve into letters.

USE YOUR CRITICAL EYE

Look for the oval inside the oval. Often, we're fixated on the lines drawn and not the interior spaces that are empty. With a brush pen, you're actually drawing two ovals simultaneously.

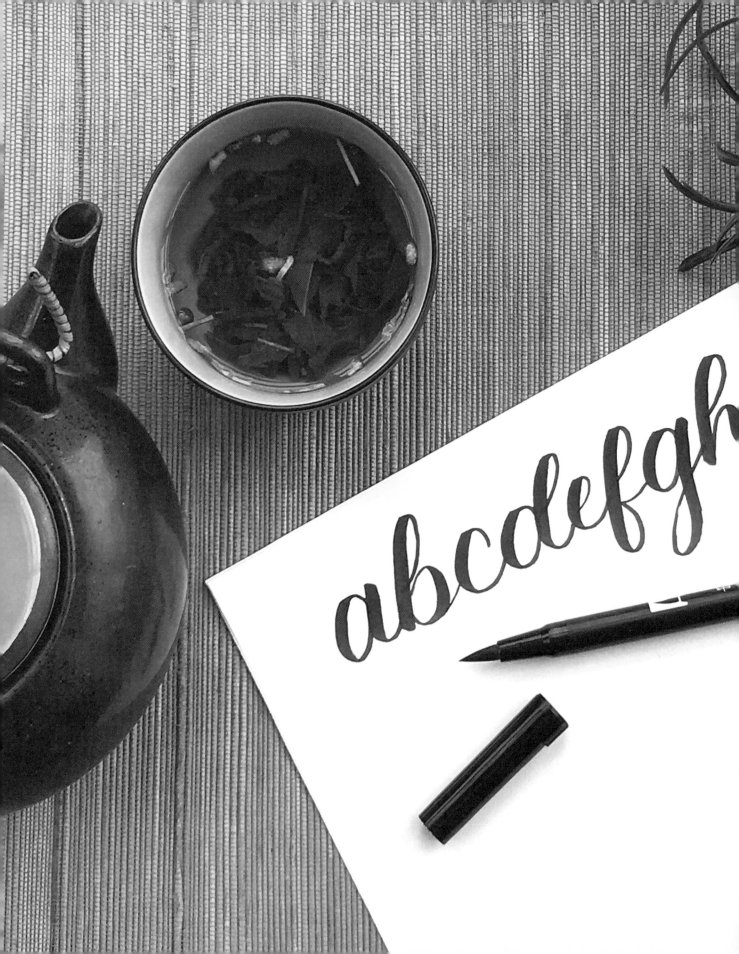

4

Lowercase Alphabet

Brush lettering is mostly described and practiced as script, fluidly written letters that are connected to one another, similar to cursive handwriting. Brush script is also called brush calligraphy, but you can print with a brush pen too, which falls into the realm of *hand lettering*.

In this chapter, the lowercase alphabet is presented as script using a large brush tip pen, following the same order as the basic strokes in chapter 3. The identical technique is used for writing with a small brush tip pen; there are alphabet tracing sheets for both sizes of pens in chapter 8.

BEFORE YOU BEGIN

As mentioned in chapter 3, when learning brush script, we don't study the letterforms in alphabetical order. Rather, we progress from simple letters with few curves to more challenging letters with ovals. This is a common instructional method in the study of calligraphy, and I've found that learners have a greater success rate and experience less frustration if they're learning in this manner.

As well, I'd like to emphasize that the letters presented here are based on my personal style of brush lettering, which is fairly standard in the world of brush lettering, but you might come across differences from one artist to the next. This is the beauty of the art form: Handwritten letters are very personal and can often be identified or associated with the artist who drew them.

After studying and practicing the basic strokes and doing drills, you'll find that drawing the lowercase letters will be much easier. Because you've already received detailed instruction and examples of the strokes in chapter 3, the explanations of these letters will be a little shorter so as not to be repetitive.

The letters are presented in five groups of increasing difficulty, according to the strokes they have in common.

So let's begin!

THE ENTRANCE STROKE

Before we study the letters, let's take a look at the entrance stroke, which is a light upstroke that's usually curved. My own entrance upstrokes tend to be straighter than most I've seen, and after practicing for a while, you'll find your own inclination.

When writing, some people like to add entrance strokes to every letter, and you can do so if you prefer; however, I've decided to be selective, so some letters will have an entrance stroke while others do not. When I'm writing entire words, I find there are some letters that look better with an entrance stroke, such as *i* or *b*, for example, but I don't usually add an entrance stroke to the lowercase *a*.

It's just a personal preference, and I like to remind everyone that your letters have to please you visually and not necessarily follow a strict structure when you develop your own style.

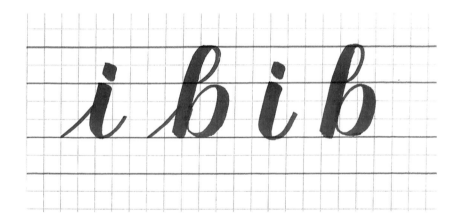

DOWNSTROKES & UNDERTURNS

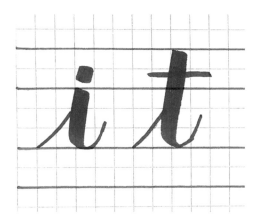

The two letters that are composed of downstrokes and underturns are the lowercase *i* and *t*.

Lowercase *i*

The very first and simplest letter to learn is the lowercase *i* because it's composed of the basic downstroke and ends with an underturn as its exit stroke.

1. Begin with a light upstroke **(fig. 1)**.

2. Starting at the waistline, apply full pressure in a downstroke **(fig. 2)**.

3. About three-quarters of the way down, begin to release the pressure gradually and curve to the right slightly until you reach the baseline **(fig. 3)**.

4. Then exit with a light upstroke **(fig. 4)**.

5. Dot your *i* with a short, heavy downstroke **(fig. 5)**. If you prefer, you can draw a circle for your dot or produce a brief square downstroke. I advise you to keep your dot the same width as the downstroke below it to be aesthetically pleasing and balanced.

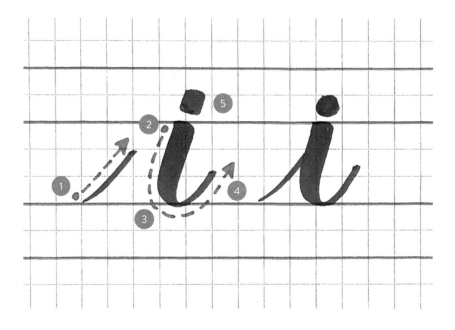

Lowercase *t*

The lowercase *t* is just a taller *i* without the dot.

1. As with the lowercase *i*, start the *t* with a light entrance upstroke (**fig. 1**).

2. The challenge of the *t* is maintaining even pressure and keeping that thick downstroke straight while you approach the baseline (**fig. 2**).

3. The transition spot is the same as the letter *i*, and the light upstroke exit finishes off the underturn stroke (**fig. 3**).

4. The cross stroke of the *t* can be accomplished in a few ways, according to your style. I cross my *t*s from left to right, and honestly, I don't usually give my *t* crossbars enough thought! I have ruined many words and projects because I have messed up when crossing my *t*s. In other words, spend a lot of time practicing crossing your *t*s (**fig. 4**). Drawing the thin horizontal line is challenging for many, but I do recommend you practice this to improve your steadiness.

5. If you're struggling with crossing the *t*, you can draw a wavy line. Some people cross their *t*s from right to left and create a longer line (**fig. 5**). Experimenting with *t*s and cross strokes is explored further in chapter 6.

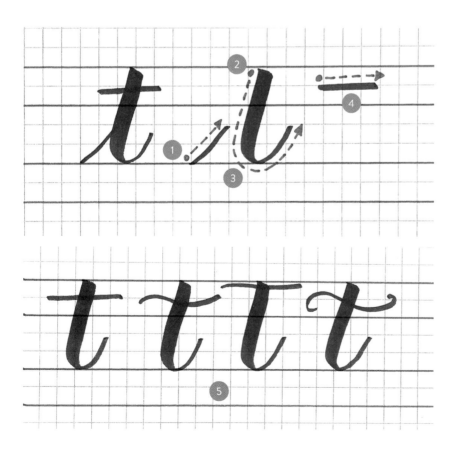

OVERTURNS & COMPOUND CURVES

The letters composed of overturns and compound curves are lowercase *n*, *m*, *u*, *w*, *v*, and *x*.

These letters have more than one transition of pressure with the introduction of the compound curve. The letters *v*, *w*, and *x* have compound curves that are modified, but the foundation is still the same curve.

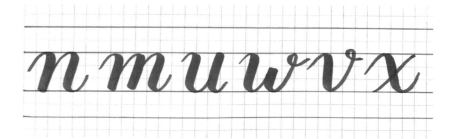

Lowercase *n*

The lowercase *n* is composed of an overturn and a compound curve.

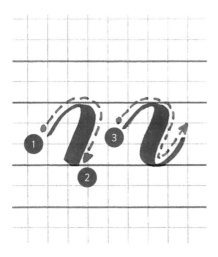

1. The starting point of the letter *n* is usually halfway up between the baseline and waistline, but this can be adjusted according to your preference. Essentially, you're drawing an overturn stroke that starts higher than the baseline (**fig. 1**).

2. After you draw the overturn of the *n*, you'll end with full pressure at the baseline (**fig. 2**).

3. The next stroke is a compound curve. You could begin drawing the stroke at the baseline and climb up the right edge of your overturn, but I tend to start higher up (**fig. 3**).

4. No matter where you begin to draw your compound curves, the end result should be downstrokes that are parallel (**fig. 4**).

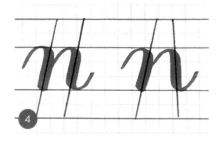

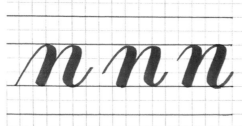

Lowercase *m*

The lowercase *m* is an extended letter *n* with three strokes combined: two overturns followed by a compound curve.

1. The goal with the letter *m* is to keep the curves consistent so they look identical (**figs. 1 and 2**). Later on, when we look at freestyle letterforms, the heights of the curves can be varied, but for now, let's work on muscle memory and perfect form.

2. Now, you have three downstrokes to keep parallel, plus they should be evenly spaced. Wherever you start your second stroke, you should also begin your third stroke (**fig. 3**).

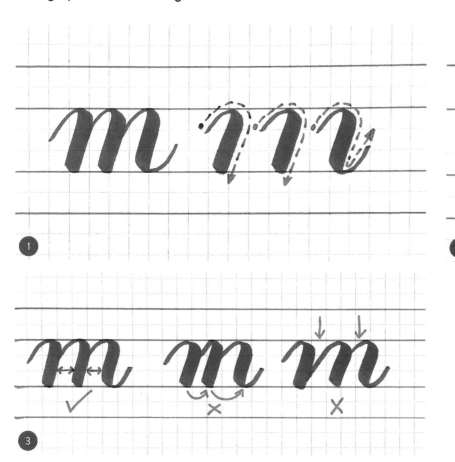

Lowercase *u*

The lowercase *u* is like an upside down *n*. In fact, a fun check for consistency is to write a series of *u*s and *n*s and then turn the paper upside down to compare them.

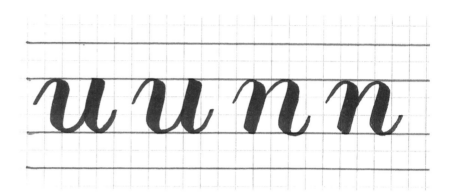

1. The letter *u* is composed of two strokes: a compound curve and an underturn. I tend to exit the compound curve high, but not right up to the waistline **(fig. 1)**.

2. The underturn that follows starts at the waistline, with full pressure **(fig. 2)**. When you place your brush pen on the paper and apply pressure, you'll learn to judge the spatial distance of that brush stroke passing alongside the exit of your compound curve.

3. If you place your brush tip too far to the left, the *u* will be too narrow, and if you're too far to the right, you'll miss touching the first stroke. Also, your underturn downstroke is parallel to the downstroke in the compound curve that precedes it **(fig. 3)**.

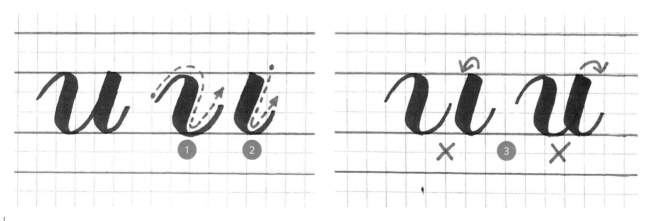

Lowercase w

The lowercase w is almost like drawing two u's together, with a little modification of the curves. I write my w with rounder bottoms.

1. I start with the compound curve (fig. 1); the ending point is the starting point of the next stroke, which is an underturn (fig. 2).

2. I like ending my w and underturn stroke with a little loop that can be a bit higher than the waistline (fig. 3).

3. Your exit loop for the w can have a little pressure or none at all. Often, I tell beginners to just use a light stroke to form this loop, and then try adding some pressure when they're more skillful because this slight touch and release of pressure is very tight and small (fig. 4).

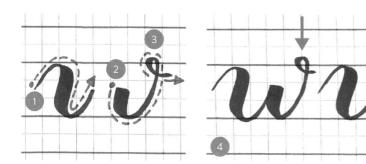

Lowercase v

The lowercase v is a single stroke without stopping. It ends in a loop similar to the w.

1. Note that the downstroke of this v compound curve does look like the letter u and even the letter w, but the light upstroke to exit moves diagonally upward to the right. I prefer a more pointed v at the baseline, which means a more difficult transition of pressure (fig. 1).

2. The one thing you don't want your v to do is to throw off the angle of the letters that are surrounding it. It's easy to relax with the v and draw it more upright, forgetting about the slant of the letter. When this happens in a word, it will look unbalanced (fig. 2).

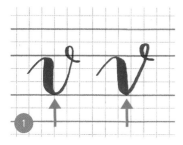 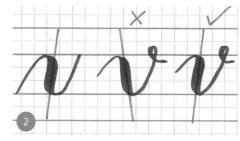

Lowercase x

I think of the lowercase *x* as a stretched-out version of the compound curve. After you draw this curve, you then add a light diagonal upstroke to finish the letter.

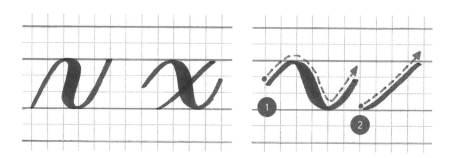

1. Although you can begin the compound curve on the baseline, my entrance stroke begins above it, about half way between the baseline and waistline **(fig. 1)**.

2. The upstroke begins on the baseline and continues as a diagonal line with lightest pressure up, crossing the compound curve at mid-point and ending at the waistline **(fig. 2)**.

3. The entrance and exit strokes of the *x* should be parallel **(figs. 3 and 4)**.

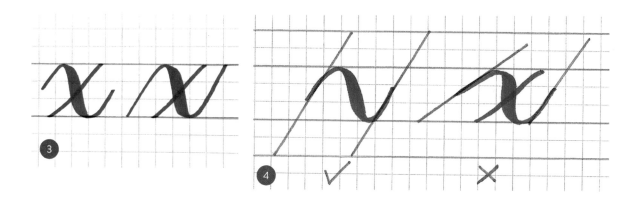

Now that you've studied this series of letterforms with overturns and compound curves, practice writing them in a line together or in various combinations so that you develop consistent angles and spacing.

ASCENDER & DESCENDER LOOPS

The letters that include ascender loops are lowercase *h*, *k*, and *l*, along with *b* and *d*. The letters *b* and *d* also contain ovals and reverse ovals and are covered in groups 4 and 5.

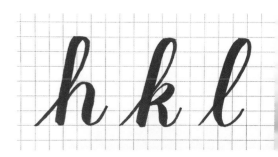

With the ascender loop, you're stretching your thin upstroke all the way to the top of the cap line. This seems like a long climb, and at first you might be shaky and uncertain, but your confidence and muscle memory will eventually kick in so you'll be ascending to the top with easy, smooth lines.

The lowercase letters that include descender loops are *f*, *g*, *j*, *q*, and *y*. *F* is a little unusual with a reverse loop. The letters *g* and *q* also contain ovals, so we will study them in the next section.

Lowercase *l*

The lowercase *l* is a study in grace and simplicity. A beautiful *l* is an elegant pirouette of a loop and a graceful exit.

1. Start with an entrance stroke (**fig. 1**).

2. Place your brush tip on or to the right of the end of the entrance stroke and draw a light diagonal upstroke. Just before the cap line, curve to your left and then touch the cap line. This is the beginning of your pressure and downstroke (**fig. 2**).

3. On your descent, you'll have full pressure (approximately at the waistline) and then lighten your pressure completely when you reach the baseline (**fig. 3**). Just before the baseline, you'll have the lightest pressure to continue your upstroke exit. Lightly curve at the baseline to your right and exit with the lightest possible upstroke, just like you would with an underturn (**fig. 4**).

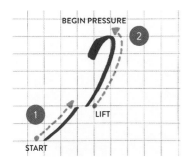
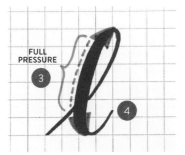
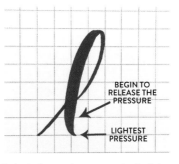

The two key points with the letter l come when you touch the cap line and the baseline. At both these points, you apply the lightest pressure possible. These two transition points take time to master. Changing the pressure from thick to thin or thin to thick is a skill that's perfected with a lot of practice.

Lowercase *h*

The lowercase *h* is composed of an ascender loop and a compound curve.

1. Start with an entrance stroke **(fig. 1)**.

2. Pause or continue with a light diagonal upstroke line. Just before the cap line, curve to your left and then touch the cap line. This is the beginning of your pressure and downstroke. On your descent, apply full pressure right to the baseline. Pause and lift. Think about your compound curve coming next **(fig. 2)**.

3. The next part is the compound curve, so you'll lightly curve upward toward the waistline and then begin to apply pressure as you move the pen downward, reaching full pressure halfway to the baseline. At this point, begin to release pressure until you're at the baseline and can exit with a light upstroke **(fig. 3)**.

4. You can alter the style of your *h* by simply moving and modifying the compound curve **(fig. 4)**.

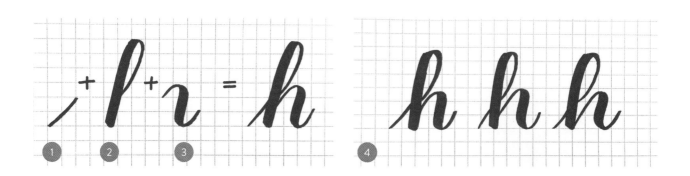

Lowercase *k*

The lowercase *k* involves an ascender loop and then two other small curves to complete it.

1. Start with an entrance stroke and then pause or continue with a light diagonal upstroke line. Just before the cap line, curve to your left and then touch the cap line. On your descent, apply full pressure right to the baseline **(figs. 1 and 2)**.

2. Begin the teardrop curve just beneath the base of the ascender loop. Move slightly upward to your right, applying half-pressure, and come back to the same point to your left by lightening the pressure. You can pause and lift at this point to consider your compound curve exit **(fig. 3)**.

3. Place your brush tip lightly where you left off and then move diagonally downward to your right, applying half-pressure. Release the pressure before touching the baseline and exit with a light upstroke **(fig. 4)**.

NOTES ON THE LOWERCASE *k*

Before you begin, take a close look below at the second part of the letter *k*: a teardrop curve and a slight compound curve exit. Half-pressure is exerted when executing these smaller curves. For these parts, I rarely exert full pressure because of the small curving maneuver. However, if your letter *k* is bigger than this, you can exert more pressure and keep your transitions clean.

Keep in mind that you're not changing your grip or the angle of the pen.

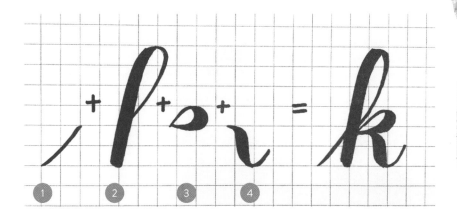

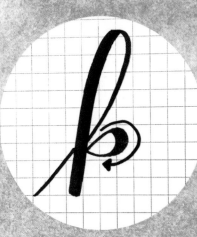

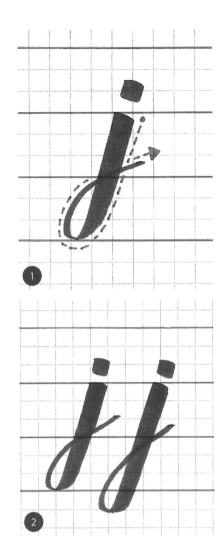

Lowercase *j*

The lowercase *j* is the descender loop as a basic stroke with an added dot on top.

1. As discussed in chapter 3 (see page 47), you begin with full pressure and descend past the baseline to the descender line **(fig. 1)**.

 Where is the descender line? Often, mine is actually much lower than most, which just seems to be the way I write. I tend to prefer my descender loops a little longer than twice the size of the x-height **(fig. 2)**.

2. Your goal is to create a loop the same size as the ascender loops you have just practiced to create consistency and harmony. Similar to the letter *i*, the dot on top can be round or a brief thick downstroke, in a square shape.

Lowercase *y*

The lowercase *y* is composed of a compound curve and a descender loop.

1. Just like the letter *u*, begin drawing the compound curve **(fig. 1)**.

2. Then instead of placing an underturn stem alongside the exit stroke, you'll draw the descender loop **(fig. 2)**.

3. I continue the exit stroke as a diagonal light upstroke by crossing over the descender downstroke at the baseline **(fig. 3)**.

4. Similar to the *u*, the downstrokes in the *y* are parallel **(fig. 4)**.

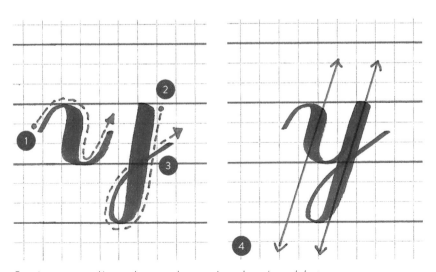

Practice your ys and js together to work on consistent loop size and slants.

Lowercase *f*

When it comes to the lowercase *f*, we have a combination of an ascender loop and descender loop combined in one stroke; however, the descender loop is reversed and drawn on the right side of the downstroke, not the left.

1. I often draw my letter *f* with the entrance stroke as an integral part of a diagonal upstroke to create that ascender loop, but you can also draw them separately **(fig. 1)**.

2. There are many variations of the height of the letter *f* and its extension below the baseline. Usually, my *f* does not reach the cap line, and the top of the ascender loop is between the waistline and the cap line. Similarly, my descender loop part of the *f* does not quite reach the descender line either **(fig. 2)**.

3. When the reverse descender loop comes back up, I draw it to meet the downstroke at the baseline **(fig. 3)**.

4. Then, I exit with a light upstroke to the right **(fig. 4)**.

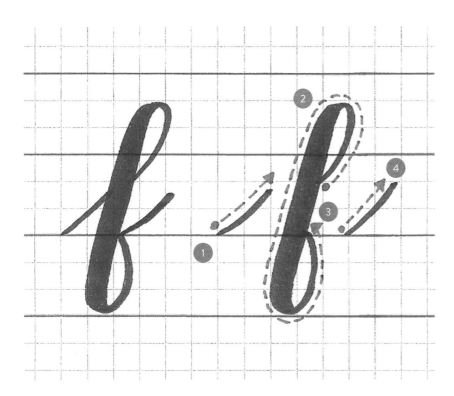

The letters that are composed of ovals are lowercase *a, c, d, e, g, o,* and *q.*

Can you believe that it's taken this long to get to the first five letters of the alphabet? Although *a, b, c, d,* and *e* come first, they're learned last because they're composed of the oval shape (and reverse oval), which is the most difficult stroke to master.

Let's look at a simple oval letter: the lowercase *o.* I present a few variations, and you can decide which one you prefer.

Lowercase o

The first lowercase *o* is identical to the oval you practiced in chapter 3, except a small exit stroke is added. The second *o* is the oval again with a bigger loop as the exit. The letter *o* that I write the most is also easiest for beginners because it begins on the left curve.

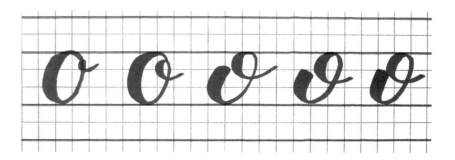

1. Instead of starting on the right side, you begin on the left curve with full pressure (**fig. 1**).

2. When you curve around back up to the waistline, you draw a loop to close the top of the *o* and exit (**fig. 2**).

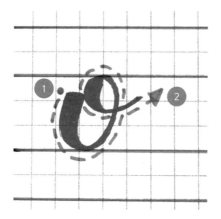

Lowercase *a*

The lowercase *a* is composed of the simple oval followed by an underturn as the stem.

1. The key to drawing letters with ovals combined with another stroke is to pay attention to the interior of the oval and keep its integrity (**fig. 1**).

2. In other words, draw your second stroke beside or alongside the right edge of the oval, without encroaching on the negative space inside (**fig. 2**).

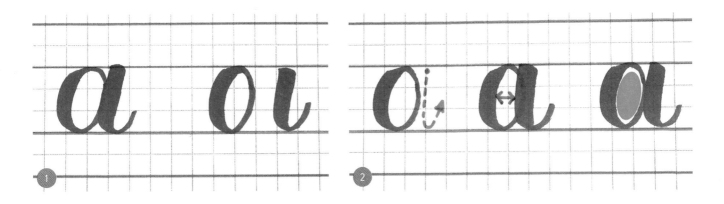

Lowercase *c*

The lowercase *c* is part of an oval with an early exit, leaving the right side open. Instead of meeting up to complete the shape, you exit with a light upstroke to the right.

1. I often begin my letter *c* with an entrance stroke (**fig. 1**).

2. I start the main shape of the *c* a little below the waistline, pretty much where I start all my oval shapes (**fig. 2**).

3. Before exiting, I do create a rounder, wider curve at the baseline so my exit upstroke could easily be connected to the next letter when writing a word. Otherwise, the *c* will seem too crowded or close to the letter following it (**fig. 3**).

4. Even though the curve at the baseline is more open than the original oval shape, the integrity of the oval structure is intact (**fig. 4**).

Lowercase *e*

The lowercase *e* is a variation of the oval with a different starting point, but it still maintains a nice oval shape and similar slant.

1. Practicing the letter *e* with an entrance stroke helps with consistent form because, in general, you can begin to draw the *e* oval where you left off at the top of the entrance stroke **(fig. 1)**.

2. Starting about halfway between the baseline and waistline, you lightly curve up and to the right to where the original oval shape usually starts. The transitions of pressure remain the same after you reach the waistline and begin to curve down and eventually exit with a light upstroke, just like the letter *c* **(fig. 2)**.

3. The goal with the *e* is not only to maintain that nice oval form, but also to create a lovely teardrop shape in the top half **(fig. 3)**.

Drawing a series of lowercase *e*s together with similar shapes and identical teardrops is an important skill because many words you will write will have more than one *e*, and when they are harmonious in form, the writing will be much more visually pleasing.

Lowercase *d*

The lowercase *d* is composed of an oval and an ascender loop, which is actually the letter *l* because of the exit stroke.

1. After drawing the oval, I place the tip of the brush beside the meet-up point (where the oval started and ended) and begin drawing the ascender loop from there **(fig. 1)**.

2. Similar to the letter *a*, we want the downstroke to be beside the oval, not cross into its interior space. Remember, the ascender stroke is drawn so that there is a teardrop-shape loop with a nice curve inside. Often, the exterior top edge of the loop will look fine, but the interior teardrop will be misshapen **(fig. 2)**.

Lowercase *g*

The lowercase *g* begins like the letter *a* with the oval and stem.

1. Begin drawing the letter with an oval and continue the stem of the *g* downward into a descender loop **(fig. 1)**.

2. The exit is the same as the other descender loop letters we've already covered, the *j* and *y*, with the light diagonal upstroke **(fig. 2)**.

3. Checking the interior spaces is also relevant while practicing and improving **(fig. 3)**.

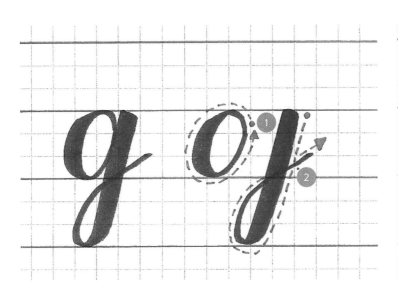

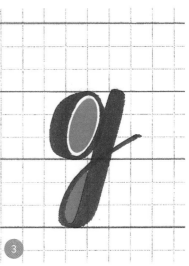

Lowercase q

The lowercase q has an oval and a reversed descender loop, but it starts out being written just like the letter g.

1. Instead of the loop curving to the left, we're thinking of the letter f and creating the loop on the right side of the downstroke **(fig. 1)**.

2. The exit of the letter q is important because it's always followed by the letter u when writing in English. It's good practice to write this letter combination whenever practicing the q. The exit of the q turns into an entrance of the u that can either be a compound curve or just a simple upstroke that touches the side of the u's underturn stroke **(fig. 2)**.

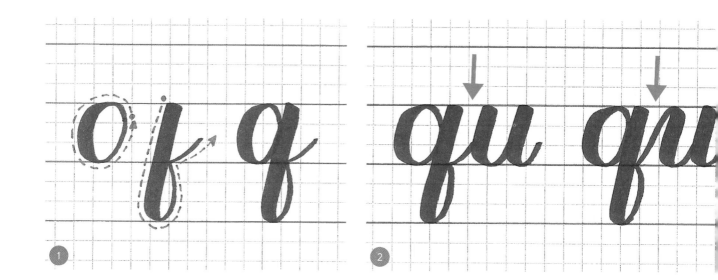

GROUP 5: LETTERS WITH REVERSE OVALS

There are also lowercase letters that are composed of reverse ovals. They are *b*, *p*, and *z*.

Ideally, your reverse oval shapes look just like the mirror image of your ovals; but even if that's not the case, if they are similar, then that's just fine. There are also a couple of shortcuts and modifications to change up the reverse oval letters and make them your own.

Lowercase *b*

The lowercase *b* is composed of an entrance stroke, an ascender loop, and a reverse oval.

1. The reverse oval begins just below where the ascender loop begins on the ascender stem. When you're finishing drawing that oval, you're on the right edge of that thick downstroke of the ascender (**fig. 1**).

2. The other way to write the letter *b* is to finish the reverse oval with a loop and exit stroke (**fig. 2**).

3. The technique shown in step 2 is popular because many people like the way this creates a connection to the next letter. If your oval is intact, you would connect by adding a separate entrance stroke (**fig. 3**).

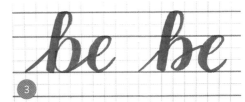

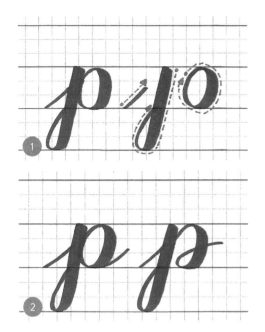

Lowercase *p*

The lowercase *p* is composed of a descender loop and a reverse oval.

1. I like to begin the letter *p* with an entrance stroke for balance **(fig. 1)**.

2. You can also alter the exit stroke of the reverse oval, just as you did with the letter *b*, for a different connection variation **(fig. 2)**.

Lowercase *z*

The lowercase *z* is a variation of the reverse oval with a different starting point combined with a curvy descender loop. Some people use the printed version too with wavy horizontal strokes and thick diagonal downstroke.

1. The starting point for the script *z* is on or above the baseline, and the reverse oval begins with a long light upstroke curving toward the waistline. The return to the baseline with a thick curve is more oblong shaped than oval or round, and the touch at the baseline is light pressure **(fig. 1)**.

2. After pausing, the next stroke is a descender that curves out to the right and then back left for the loop formation **(fig. 2)**.

3. Your goal with the letter *z* is to make the strokes in both upper and lower curves the same thickness. Also, pay attention to the angle of this descender loop because its shape is slightly different that the regular loop **(fig. 3)**.

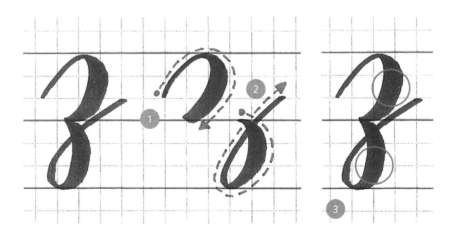

THE UNIQUE LETTERS

Two letters make up their own group: the lowercase *r* and *s*.

Lowercase *r*

When I first learned brush lettering, I didn't like the letter *r*. I thought it was ugly and weird to write. The more I practiced, the more I came to love it. I especially like the way you can modify it to make it dramatic or understated.

1. Starting at the baseline, draw a light upstroke, and above the waistline, create a loop, exiting to your right. You can slant downward or keep this light exit stroke fairly horizontal **(fig. 1)**.

2. You can pause at this point and even lift your pen, but I continue with full pressure and draw the underturn, exiting with an upstroke **(fig. 2)**. Stopping and lifting between these two parts of the *r* is fine, but I tend to write it as a continuous form.

3. My standard letter *r* has a loop on top. This loop rises a little above the waistline and can have a quick transition of pressure to add thickness or not **(fig. 3)**.

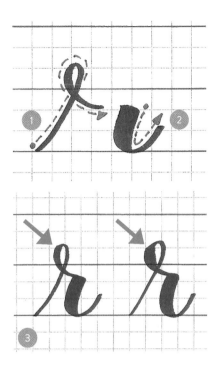

Lowercase *s*

My initial feelings about the lowercase *s* were opposite of the letter *r*. I just love its graceful, sweeping curves.

1. Similar to the letter *r*, start with a light upstroke and loop at the top above the waistline. Continue without lifting and begin pressure on a downward right slant, increasing briefly to full pressure to create the outward curve of the s. Halfway down, when you have full pressure, release and curve down to the left toward the baseline, where you can either exit with lightest pressure by touching the entrance stroke or by drawing a loop and exiting up to the right **(figs. 1 and 2)**.

2. As soon as I started to write the lowercase s, I developed a loop on top and an exit loop as well. The top loop rises above the waistline and continues down with pressure, but you can eliminate this loop completely if you prefer to have a simpler, more traditional letter s **(figs. 3 and 4)**.

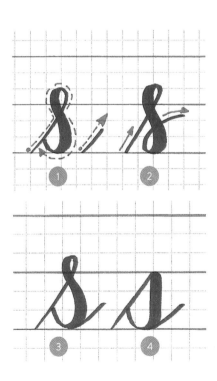

A B C D
F G H I
L M N

5

Uppercase Alphabet

The uppercase alphabet is learned after the lowercase alphabet is mastered because the degree of difficulty is higher. The capital letters are more challenging forms because of their size, and the strokes are longer and taller, which demands greater control.

There are many different styles of uppercase letters derived from traditional calligraphy alphabets, and I present a simple, classic style that I use often and most beginners enjoy learning. We progress in alphabetical order, assuming you have studied and become proficient with the lowercase letters.

BEFORE YOU BEGIN

It's a good idea to remember the value of drills, and when you're preparing for the uppercase letters, increase the size of your drills and basic strokes so they stretch from the baseline to the cap line, instead of halfway. This will really help your pen control when you sit down to practice your capital letters.

Capital A

The uppercase A is a nice, easy introduction into capital letters and larger strokes. With a simple sweep upstroke followed by a downstroke, this letter can be mastered quite easily.

1. You're beginning at the baseline and climbing with lightest pressure diagonally all the way to the cap line. After touching the cap line with a slight curve, you apply full pressure almost to the baseline and then release the pressure to exit with a light upstroke **(fig. 1)**.

2. About halfway, at the waistline, draw a wavy cross stroke with brief pressure applied in the middle. You begin this cross stroke with light pressure and end with light pressure **(fig. 2)**.

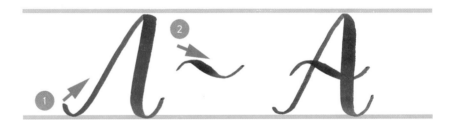

Capital *B*

The uppercase *B* begins with a simple entrance stroke and stem with full pressure. This will also be the first stroke of the letters *D*, *K*, *M*, *N*, *P*, and *R*.

1. The light entrance stroke begins at about x-height and curves to touch the cap line. Then, full pressure is applied as a downstroke to the baseline **(fig. 1)**.

2. The first top curve of the *B* is similar to the reverse oval. The brush tip touches the stem and then moves up, out, and in **(fig. 2)**.

3. The second curve begins where the top curve ends and is drawn with a similar motion and pressure but is slightly larger **(fig. 3)**.

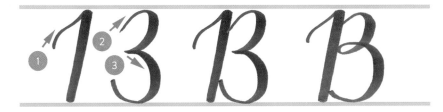

Capital *C*

The uppercase *C* might look simple, but I think it's one of the more difficult letters to execute. If you thought a small oval is challenging, then a partial large oval is trickier!

1. I like the uppercase *C* to have a little bit of interest with a wave entrance stroke and small loop at the very top. You could leave this out and just draw a simple part oval for the *C*, but I think the entrance with loop fits in well with the style of the rest of the uppercase letters in this alphabet **(fig. 1)**.

2. The key is finding a starting point to the left and moving fluidly across, creating the loop and continuing around to draw a nicely shaped large oval **(fig. 2)**.

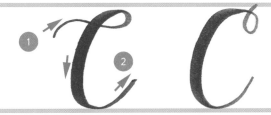

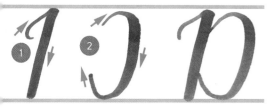

Capital *D*

The uppercase *D* has a significantly large reverse oval that requires careful navigation. The size of this reverse oval can be altered to create quite different appearances, which means it takes a lot of practice to make this stroke consistent.

1. We begin the uppercase *D* the same way as the uppercase *B*, with a wavy entrance stroke and a full pressure downstroke **(fig. 1)**.

2. Now, we add a modified reverse oval. Start with the tip of your pen near or on the right edge of the stem and move upward and outward, applying pressure. You have full pressure while curving outward, and then you'll start to release as you curve down and toward the baseline. At the baseline, you're at the lightest pressure, and then finish the stroke by returning upward to the stem again **(fig. 2)**.

Capital *E*

Think about the uppercase *E* as the reverse of the uppercase *B*, without the stem. There are two stacked ovals that vary in size, and you can create many different versions by changing the heights of these curves.

1. The uppercase *E* begins similarly to the uppercase *C*, with a wavy entrance stroke near the cap line, moving from left to right **(fig. 1)**.

2. Then, you draw two stacked half ovals **(figs. 2 and 3)**.

3. You can pause, lift, and assess before you draw your second half oval.

4. Always approach the baseline with lightest pressure and continue the oval up partway toward the waistline.

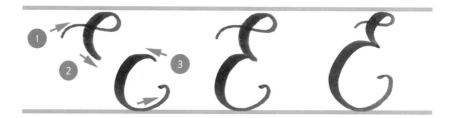

Capital *F*

The uppercase *F* is one of the easier letters, because the stroke is simple and easy to implement, with a light horizontal entrance and a stem at full pressure. With a few changes, you can draw the uppercase *I* and *T* as well.

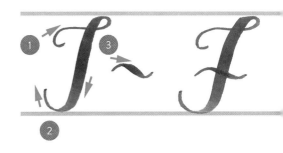

1. The entrance stroke of the uppercase *F* begins with a wavy line drawn from left to right, just below the cap line and ends with a light loop, followed by a transition into pressure downwards to draw the stem (**fig. 1**).

2. The downstroke begins at the cap line after the loop is completed and then releases near the baseline, curving to the left and touching the baseline with lightest pressure. The exit curve continues up to the left (**fig. 2**).

3. The letter is finished with a wavy cross stroke (**fig. 3**).

Capital *G*

Because the uppercase *G* has a descender, its upper oval doesn't reach the cap line. This is how I prefer to draw the letter *G*; otherwise, it looks too top heavy and odd, with the descender loop making it too large in comparison to the other capital letters.

1. Begin with a wavy entrance stroke and loop, just above the waistline, drawn lightly from left to right, and draw a large oval shape (**fig. 1**). I often leave the oval open on the right side and do not meet up, but you can also close the gap.

2. Then draw your descender loop with full pressure, wherever you left off with your oval (**fig. 2**).

The letter *G* is one of my favorite uppercase letters because of the graceful lines of the loops and oval.

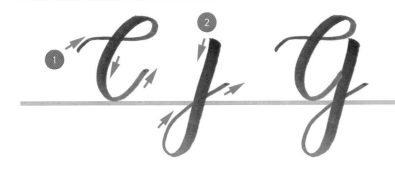

Capital *H*

The uppercase *H* is a beautiful, balanced letter that has pleasing symmetry. The basic version of this letter is classic in itself, while the "loopy" version is an exercise in grace.

1. The entrance stroke of the uppercase *H* is similar to the uppercase *B* and *D*. A light wavy upstroke approaches the cap line. Then, a thick downstroke moves downward at a slight angle. Instead of stopping with full pressure at the baseline, we will release the pressure and curve with a light upstroke to the left to exit **(fig. 1)**.

2. The second stem of the *H* starts with a small, light, curved entrance up to the cap line and then full pressure toward the baseline. Again, like the first stroke, release the pressure and exit, but this time a light upstroke curves to the right **(fig. 2)**.

3. The final stroke is a horizontal swash across the midpoint **(fig. 3)**.

4. An alternative uppercase *H*, which is more advanced and I really enjoy, consists of a single stroke of stems and loops. When you have a rhythm of drawing these loops in this *H*, it serves in a fun drill of consistency and spacing in and of itself **(fig. 4)**.

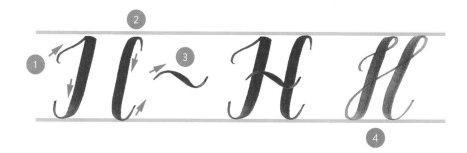

Capital I

Many people complain that the uppercase I looks like a J or a T, and they struggle to distinguish among the three. I believe that this style of I, which is quite narrow, leaves no doubt as to what letter it is.

1. Beginning at or a little higher than the waistline, with a light upstroke, move up and curve to the left briefly and then move lightly up to the cap line, toward your right again. This creates space for a loop when you draw your downstroke **(fig. 1)**.

2. At the cap line, you can draw a little loop or a point and then apply full pressure in a downstroke, releasing the pressure before the baseline and exiting with a small curve up to your left **(fig. 2)**.

3. An alternative uppercase I is composed of three strokes: a downstroke and two swashes or cross strokes, one at the cap line and one at the baseline **(fig. 3)**.

Capital J

Now we'll see how different the uppercase J looks in comparison to the uppercase I you just completed.

1. I like to begin the uppercase J just above my baseline because I like to exit at the baseline to complete the letter. With a light upstroke, move across and up, curving outward and then back to the right toward the cap line. You will not touch the cap line, but your top curve, loop, or point will be below it, similar to the letter G **(fig. 1)**.

2. Then, you will apply pressure and come down at a slant, past the baseline to the descender line, where you touch and then curve to your left to create your descender loop. With a light upstroke, you will draw a diagonal line and cross the J downstroke at the baseline to exit **(fig. 2)**.

3. If you prefer, you could add a little loop to the top of your J or a point, instead of creating a curved top **(fig. 3)**.

Capital K

The uppercase K is a letter that often disappointed me until I understood the pressure adjustments of its arm and leg. When I began learning calligraphy and lettering, I really wanted to love the uppercase K because of my name. It's been a struggle, but now I'm happy to announce that this letter and I are on good terms.

1. The opening stroke for the uppercase K is the entrance and full downstroke just like the letters B and D **(fig. 1)**. Sometimes, I add a left curve at the baseline similar to the uppercase H.

2. The second part of the letter K consists of two strokes. The first one begins with a little *hook* or curve at the cap line and moves with diagonal half-pressure to the midpoint of the stem **(fig. 2)**. Then pause.

3. At this point, you can place the tip of the brush where you just left off, or you could create a little loop on the other side of the stem and then draw your second diagonal line down to the right. Lighten the pressure before the baseline and then curve upward in a little underturn to exit **(fig. 3)**.

In both the lowercase and uppercase Ks, the arms of the K are drawn with half-pressure as diagonal strokes. The shape of these diagonal strokes can vary in terms of adding curves.

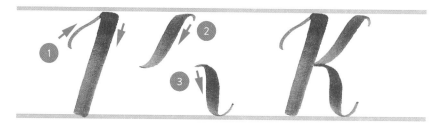

Capital L

I often think of the uppercase *L* as the perfect letter to draw for a first name because of its gentle, sweeping motion.

1. I complete the *L* in one continuous stroke, beginning with a wavy light entrance stroke just below the cap line, moving horizontally to the right **(fig. 1)**.

2. I draw a loop with light pressure and then begin to apply pressure, gradually creating a thick downstroke on a slant to the left until reaching full pressure at the waistline. Continue with a thick downstroke and begin to release pressure before the baseline **(fig. 2)**.

3. Before the baseline, I release the pressure and draw a second loop to the left. This loop ends with a light, wavy swash across the baseline **(fig. 3)**, which sometimes moves a little below the baseline and then comes back up to exit **(fig. 4)**.

Capital M

There are many fun, freestyle variations of the uppercase *M*. We discuss them in the next chapter.

1. The uppercase *M* begins with an entrance downstroke, just like the letter *B* **(fig. 1)**.

2. The next two strokes are an overturn and compound curve, both beginning near the waistline. Place the tip of the brush at the middle of the downstroke or stem and then execute an overturn, with light pressure going up and heavy pressure going down. I don't return to the baseline with this stroke; I prefer to stop at about the waistline or just below **(fig. 2)**.

3. The third stroke, the compound curve, begins where the first overturn left off, and a second arch is drawn to look identical to the first **(fig. 3)**. The downstroke is at full pressure and parallel to the lines of the first curve (just like the lowercase *m*) and then the pressure is released before the baseline, with a light upstroke to exit.

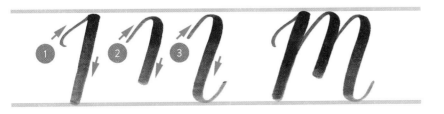

Capital N

You've already practiced the uppercase N while learning to draw the uppercase M. The uppercase N is composed of the first stroke and the last stroke of the M.

1. A light wavy entrance stroke begins along with a heavy downstroke (fig. 1).

2. Then a compound curve follows to complete the N (fig. 2).

A helpful practice is to draw uppercase Ms and Ns, alternating to create those consistent, identical curves.

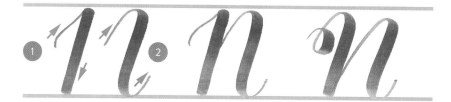

Capital O

There are a number of ways to draw an uppercase O, but I prefer the simple, classic style with a small loop.

1. Begin slightly below the cap line and curve upward to the left to touch the cap line with light pressure (fig. 1).

2. Transition to full pressure to create the downward left curve (shade). As you approach the baseline, release the pressure and curve to the right, touching the baseline with lightest pressure and curving upward (fig. 2).

3. Finish the oval with a light upstroke, curving to meet up with the starting point. After reaching the cap line, draw a loop with brief pressure applied and exit with a light stroke to the right (fig. 3).

4. Instead of meeting up at the cap line, you can also draw the exit loop of the O inside and under the starting point, leaving a space. Variations of the size of the exit loop can also be drawn (figs. 4 and 5).

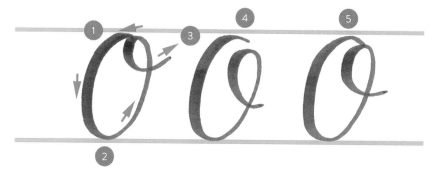

Capital *P*

Traditionally, the uppercase *P* extends below the baseline; however, I prefer the look of it standing on the baseline.

1. The beginning strokes are identical to the letter *B* and others with a light entrance stroke and a heavy downstroke to the baseline **(fig. 1)**.

2. Then a reverse oval is drawn at the top **(fig. 2)**.

3. When drawing the reverse oval, you can make more of a curve or loop at the exit **(fig. 3)**. Adding simple curves and loops to letters adds an element of style that is easy to execute, but it's not quite a fancy flourish.

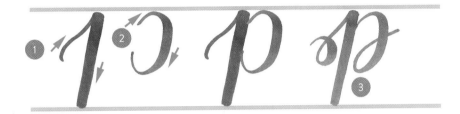

Capital *Q*

The uppercase *Q* begins with the same form as the uppercase *O*; however, you can vary the size and positioning of the swash to create some interesting variations.

1. To maintain a consistent alphabet style, you can draw the oval of the *Q* exactly the same as the capital *O*. I choose to alter it somewhat and draw the *Q* without a loop to exit **(fig. 1)**. Then add a swash across the bottom near the baseline.

2. I like to start my swash a little higher on the outside of the lower left curve of the oval and then swoop it through and slightly downward, ending a little below the baseline. The advantage of ending the stroke below the baseline is that it creates room beside the *Q* for the next letter. Otherwise, your swash will get in the way of the beginning stroke of the following letter **(fig. 2)**.

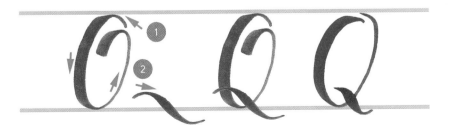

Capital *R*

Think of the uppercase *R* as a combination of the uppercase *B* and *K*.

1. Again, we draw the wavy entrance stroke followed by a full downstroke to the baseline, or you can exit with a light curve to the left, like we did with the capital *H* **(fig. 1)**.

2. The other strokes are similar to the top half of the letter *B* and the bottom half of the letter *K*. The reverse oval begins and ends at the stem **(fig. 2)**.

3. Then, you can pause and lift and consider the leg of the *R*, which starts out with light pressure and quickly transitions into full or half-pressure, exiting with a light upstroke **(fig. 3)**.

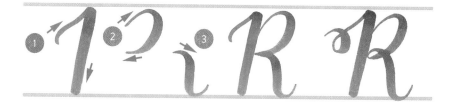

Capital *S*

I prefer the traditional script *S* that is written in one stroke; however, a stylized printed *S* is also popular.

1. Beginning on the baseline, climb all the way up to the cap line with a light diagonal upstroke **(fig. 1)**.

2. Create a loop at the top, touching the cap line, and transition to full or half-pressure, curving out and down to draw the shade, or belly, of the *S* **(fig. 2)**.

3. Lighten up the pressure as you curve to the left toward the baseline, touch and curve upward, and curl in to finish the stroke **(fig. 3)**.

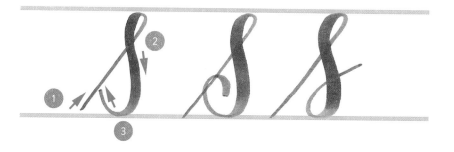

Capital *T*

The uppercase *T* is almost identical to the letter *F*, but without the cross stroke.

1. Start with the wavy entrance stroke from left to right, near the cap line **(fig. 1)**.

2. Then, follow with a full-pressure, slanted downstroke, releasing the pressure before the baseline. Create a curve with a light stroke upward to your left to exit **(fig. 2)**.

3. Another alternative is to draw the *T* with two separate strokes: the swash at the cap line and a stem **(fig. 3)**.

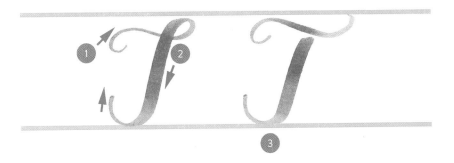

Capital *U*

The uppercase *U* is composed of a compound curve and underturn.

1. I like to begin my uppercase *U* with a curvy entrance stroke to add some interest and gracefulness. You can make this more elaborate as you progress in your skills, but, as a beginner, keep the entrance a light stroke **(fig. 1)**.

2. After your curvy entrance, you touch the cap line and begin to apply pressure downward at a slight angle, releasing the pressure and curving to the right to touch the baseline. Exit with a light upstroke, which reaches the waistline **(fig. 2)**.

3. Start up at the cap line again for your underturn stroke and push with heavy pressure down so you touch the end of the compound curve stroke to join the two together. Lighten the pressure before the baseline and exit with a light upstroke **(fig. 3)**.

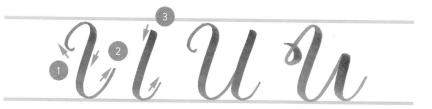

Capital *V*

The decision to make when drawing an uppercase *V* is how pointy you want the letter at the baseline. I like a pointy *V*, with a late release of pressure so that it's almost full pressure down to the baseline.

1. I begin with a curved entrance and slant downward with full pressure from the cap line **(fig. 1)**.

2. Just at the baseline, I release the pressure and do a very tight turn up with a hairline upstroke on an angle all the way back up to the cap line **(fig. 2)**. I love the drama of this *V*!

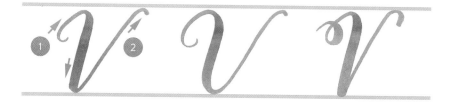

Capital *W*

The uppercase *W* is composed of a compound curve and an underturn that are simply larger versions of the lowercase *w*.

1. Similar to the letter *V*, the *W* starts with a curved entrance and then has full pressure down to the baseline. Pressure is released before the baseline with a rounder curve upward with a light upstroke. I stop the upstroke at about the waistline. The bottom curves of the *W* at the baseline are rounder than the pointy *V* **(fig. 1)**.

2. I begin the second compound curve where I left off the first, with full pressure curving toward the baseline. Before the baseline, release the pressure and touch the baseline and curve upward with a light upstroke, exiting with a small loop at the cap line **(fig. 2)**.

The *W* is also an easy letter to play with in terms of form, making the curves rounder, wider, higher, and lower, which will be demonstrated in chapter 6.

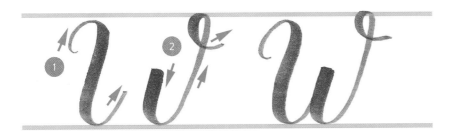

Capital X

The uppercase X is a relaxed compound curve that's intersected by a second light upstroke.

1. Begin with a light, small curve as an entrance stroke and then move down with full pressure on a slant toward the baseline. Release the pressure before the baseline and curve up with light pressure to exit (fig. 1).

2. The diagonal upstroke begins at the baseline below the starting point of the curve above. This stroke intersects the previous one at the waistline and continues to rise up to the right to touch the cap line above the end of the exit stroke below (fig. 2).

 Do I use the uppercase X much? Not at all, but it is a lovely letter to write!

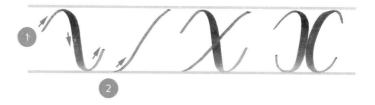

Capital Y

The uppercase Y is composed of a compound curve and a descender loop. The size of the uppercase Y is similar to the uppercase G, and with the descender loop, the upper compound curve is lower than the cap line.

When combined with other letters, the uppercase Y is slightly taller than the waistline or x-height.

1. Basically, you're writing an uppercase U shape that's below the cap line and curves up at the baseline (fig. 1).

2. The descender loop begins with full pressure at the same height as the compound curve and slants downward past the baseline. The loop is formed with light pressure, and the tail is drawn with an upstroke diagonal to the right, crossing the baseline where the thick downstroke intersects (fig. 2).

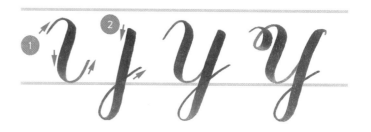

Capital Z

The uppercase Z is another letter that is rarely written. There are two versions, and I prefer the simpler Z with two horizontal light strokes and one diagonal downstroke.

1. The first stroke is a simple, light, wavy line drawn along the cap line from left to right (**fig. 1**).

2. Where the horizontal stroke ends, apply full pressure downward at a diagonal that approaches the baseline to the left (**fig. 2**).

3. Where the thick diagonal downstroke ends, begin drawing a wavy stroke with light pressure along the baseline. The beginning and end of the Z line up approximately with the top and bottom of the diagonal downstroke (**fig. 3**).

4. The second style of capital Z is a larger version of the lowercase z (**fig. 4**).

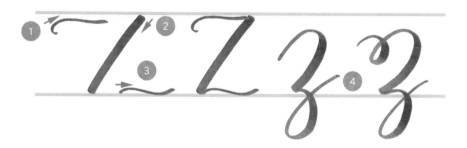

Now that you've studied the entire uppercase alphabet, you can write anything with confidence! As you improve, you'll also be able to alter these capital letters to suit your own style. If you take a look at calligraphy alphabet samples written with dip pens and ink, you'll find many other variations you can try. The possibilities are limitless.

ballet

jazz

6

Freestyle Lettering & Faux Calligraphy

Now that you've spent time learning the rules, practicing the strokes, and building up muscle memory, it's time to play with the letterforms.

Here's where your imagination and personality come together to modify the script and create different styles. You've followed the rules, and now you can break them. Or think of it this way: You've studied ballet, and now you'll learn jazz.

So take off your pointe shoes, wiggle your toes, and let's get started!

MODERN CALLIGRAPHY

Traditional calligraphy, in any style or alphabet, is very linear, with strict adherence to letter height, width, and overall form. Modern calligraphy first appeared in the wedding industry as a looser, free-flowing style of writing, and this has also been adopted by brush pen lettering artists. Whether the pen has a large brush tip or small brush tip, it's easy to mimic modern calligraphy.

Why do people like this style of writing? Probably because it's easier to draw letters and words and not worry about straight lines, uniform structure, and identical strokes. We can all admire the perfectly formed letters that we learned and studied, but we can also enjoy writing freely and more playfully in a modern calligraphy style.

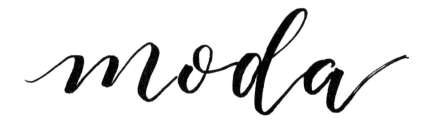

Breaking the Baseline

The key to creating a modern calligraphy look is what I call "breaking the baseline." This means that you're still writing in a fairly straight line, but some of your downstrokes and parts of letters will dip below the baseline.

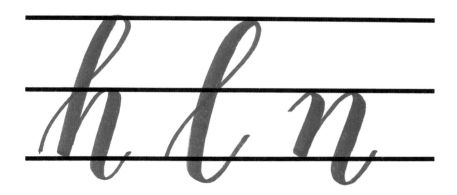

Which letters dip below the baseline? Letters with compound curves and underturns are the most common letters. The oval-shaped letters don't stretch below because they'll just look misshapen.

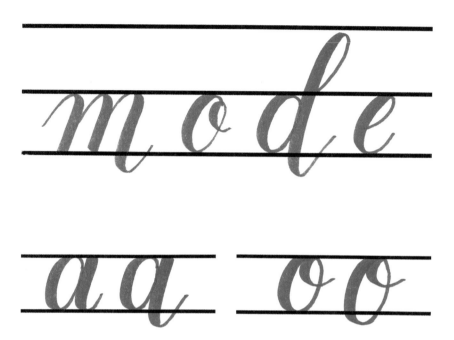

Bouncy Lettering

To create a more dramatic look, you can also raise other letters above the baseline. In fact, a common term to describe modern calligraphy is "bouncy lettering." You can see why the word *bounce* is used to describe this style—the letters appear to be bouncing up and down like a ball. If you're designing a project with this type of lettering, I recommend sketching it out with a pencil first and making a rough draft. Many people don't realize that free-style brush lettering also takes planning and design skills.

When you're experimenting with freestyle brush lettering, it's important to keep in mind that people should be able to easily read what you're writing. Sometimes, it's really difficult to decipher a whole bunch of letters bouncing around haphazardly!

Another way to add bounce to your lettering and loosen up your forms is by modifying heights of curves within single letters, especially the lower-case letters *m* and *w*.

Try changing the heights of the first curve and then the second curve. Experiment with the heights and see which one you prefer or which one suits the word you are writing.

A final modification that will help create a bouncy line is to combine different sizes of letters within a single word. You can draw some letters smaller than others and change the size of the letters from one to the next. For instance, try making all your vowels much smaller in scale than your other letters.

PLAYING WITH LOOPS

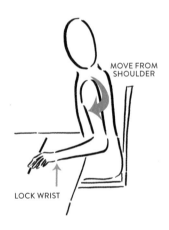

Creating playful spaces in your brush lettering can be accomplished by changing the size of your loops. Although curves are trickier to navigate, there are ways to change the size of your loops so they look wonderful, open, and free. Perhaps the best way to imbue your letterforms with a sense of freedom and openness is by dramatically enlarging the loops.

Keep in mind that we're maintaining the integrity of that teardrop interior space of the loop with lovely curves.

As soon as letterforms get bigger, however, our lines tend to get shakier. As with the flourish (see page 102), we'll change our execution of the loop's thin lines and use our arm and shoulder to stabilize and move the brush pen. As soon as you stop using your fingers to move the pen and mobilize your arm and shoulder, your drawn strokes will be significantly steadier. The loops will flow more gracefully by practicing. Maybe you're that rare person who can manipulate the large brush pen fluidly with only finger control, and that's wonderful! But most of us will benefit from activating our arms and shoulders to enlarge our loops.

The key is to keep the fingers absolutely still, gripping the pen firmly, but not tightly, and not moving them at all. Remember that the pen will move because your arm and shoulder will generate the force.

Let's take a look at modifying the ascender loops of a few letters.

Modifying Ascender Loops

One way to create a much bigger loop is by changing the entrance stroke and raising it much higher, with a starting point far to the left of the ascender stem.

Often, these exaggerated entrance strokes are used to flourish or connect another letter or part of the word. For example, a common way to connect the larger *h* ascender loop in a word with *th* side by side is to use the *h* entrance stroke to cross the *t*.

MOVE FROM
SHOULDER

LOCK WRIST

START HERE

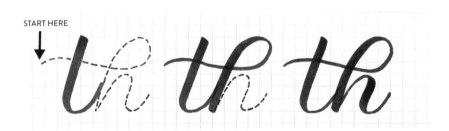

Modifying Descender Loops

Similarly, the letters with descender loops can be modified too. Because the larger loops are more playful, their sizes don't have to be identical or match, but they do need to have a similar openness and shape. On the right are some examples with the lowercase letters *g*, *p*, and *y*.

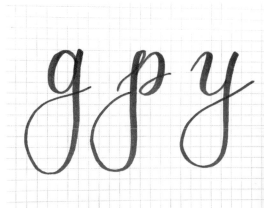

Modifying Interior Loops

Perhaps the two lowercase letters that many of us don't think of having loops that can be made bigger are *o* and *r*.

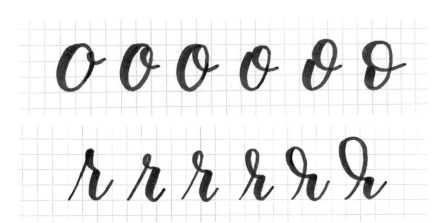

While the interior of the oval in the lowercase letter *o* maintains nice curves, the interior of the loop of the *o* does too, like a teardrop. Even when the lower part of the *o*'s oval is quite small in comparison to a dramatically bigger upper loop, the integrity of the curves remains balanced and fluid.

A general rule of thumb for enlarging loops is simply to keep them visually pleasing. After spending time learning brush lettering, you'll quickly develop a sense of what looks good and what doesn't. There's a point where you just have to trust your instincts and modify your loops until you like what you see.

Using your critical eye (see page 35) will ensure that your loops will appear graceful and smooth no matter how big or small they are.

STRETCHING

Another way to create a different style of brush lettering is by stretching out your letters by extending your entrance and exit strokes. This structure is restful for the eye because of the expanse of the strokes across the page.

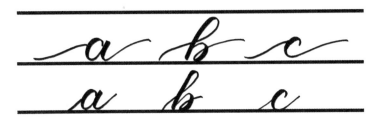

Stretching your letters is more suited to the pens with small brush tips because the space required with the larger brush pens is significant for this technique.

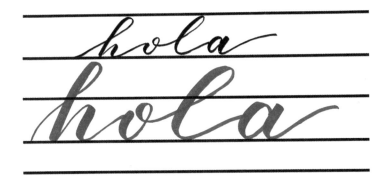

You also can combine the *stretch* with the *bounce*. (And now this is starting to sound like an exercise workout!) Remember to pick up your pencil to sketch and experiment with these styles before you commit ink to paper.

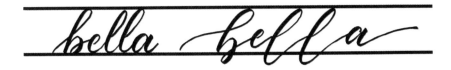

OPEN STROKES & SPACING

Relaxing letterforms can be achieved by creating some open spaces within strokes and between strokes. For example, with the oval shape, leave space instead of joining the beginning and end of the stroke.

Creating distance between compound curves and stems has a similar effect of openness.

This distance can be as exaggerated as much as you like, but I recommend exaggerating all the letters in a similar way.

BASIC FLOURISHING

Because we're focusing on beginner skills and learning the basic letter-forms, I present a few simple options to practice flourishes. As you become more confident with your technique and strokes, you can experiment more and add more elaborate flourishing at that time.

Flourishes usually are added to the first letter of a word, the last letter, ascenders, and descenders. Also, flourishes can be written *around* the space of the word and letters just to add decoration.

Flourishes can have thick and thin areas, but, in general, use a light stroke while you're learning. While drawing the flourish, lock the wrist and generate movement with the shoulder. This will keep your curves and lines smoother.

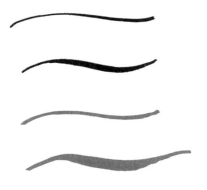

The Swash

A good starting point is the swash, which is a line that starts and ends with light pressure but has more pressure applied in the middle. You can draw a swash with both small-tip and large-tip brush pens.

A swash is subtle, but does have an impact in the design of the letter, as shown in this example of an uppercase A where the cross stroke is changed to a swash.

Types of Flourishes

Let's categorize flourishes with a few terms: wave, loop, and spiral.

Now, let's add these types of flourishes to the lowercase y.

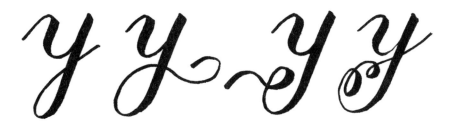

One way of practicing your flourishing is to use a pencil and draw. Start with an uppercase letter and draw a basic form. Then add some flourishing.

I admit I'm a minimalist when it comes to my brush lettering style, so I really have to push myself out of my comfort zone to draw flourishes. The more you practice drawing with your pencil, the more confident you'll feel with your brush pen.

FAUX CALLIGRAPHY

A very popular way to imitate brush lettering is called faux calligraphy. "Faux" is the French word for "fake" or "false," and I think "faux" sounds much nicer! Using a regular marker or pen, you create *fake* thick down-strokes simply by drawing and filling them in.

You can actually be quite skillful with this technique, and it can be difficult to tell the difference between fake and real brush lettering. Let's take a look at this example and try to guess which one is fake and which is written with a brush pen.

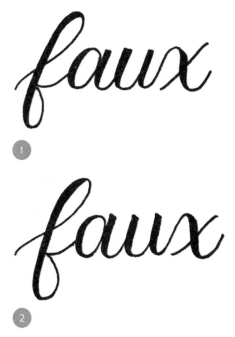

1 is real brush lettering; 2 is faux calligraphy.

Placing the Downstrokes

Where do you draw the thick downstrokes? There are varying opinions of how to add the extra thickness to letters. Some artists draw the extra lines on the inside of the original letterform, while others draw it on the outside.

I find myself doing both, depending on which looks better visually, but the rule of thumb is to maintain the integral structure of the letter. This is probably most noticeable when drawing the letters with ovals. So, generally, I add my lines to the inside.

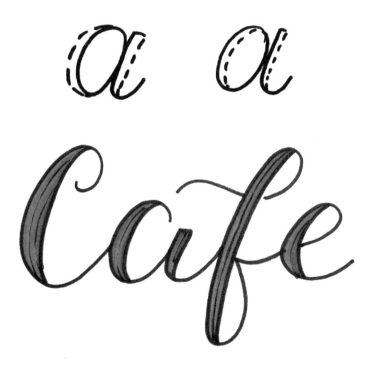

Practicing

I highly recommend practicing the alphabet first before moving on to words. When I do faux calligraphy, I write out my words with a pencil first. Then, still using a pencil, I add the extra lines to create the thick down-strokes. When I'm happy with the result, I trace over my pencil lines with a good fine-tip permanent pen and then fill in the downstrokes. I like the Sakura Pigma Micron pens that come in different size tips. After waiting awhile to make sure the ink is dry, I erase all the pencil lines.

faux faux faux

It's also fun to write faux calligraphy without filling in the interior spaces and leaving the downstrokes as outlines.

calligraphy

Any color of pen or marker can be used, not just black, for both writing and filling in the downstrokes.

latté latté

Here's a sample lowercase alphabet with dotted lines drawn to indicate where you draw the faux thick downstrokes.

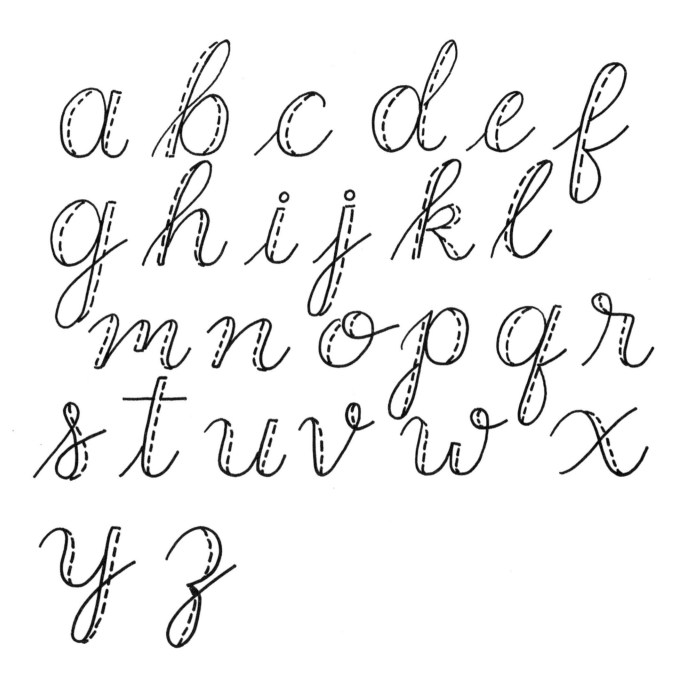

7

Special Effects

While learning how to write with brush pens, it's fun to explore some creative techniques, too. In this chapter, I share some cool ways to alter your letters and make them more dimensional with drop shadows, highlights, outlines, and patterns. Plus, we see how easily water-based brush pens can blend together to create eye-catching, colorful effects.

CREATING DIMENSION

Here are a number of ways to alter or embellish brush lettering, and perhaps the most common is the addition of drop shadows.

Adding Drop Shadows

Drawing lines beside your strokes and letters is the easiest way to create an illusion of depth and dimension. Many hand lettering artists creatively use drop shadows in every way imaginable to help make their designs *pop*, or come to life.

Where do you add drop shadows? Think of yourself standing outside in the sunlight. Where does your shadow fall? If you imagine your letters are raised 3D from the paper and a light source is shining from one direction, this will determine where your drop shadows go. Wherever your light source is shining, then your shadow will be on the opposite side. For example, I usually think of the light shining from the left of the word, so I draw shadows on the right edges of the strokes.

Deciding to represent *true* shadows is up to you, and artistically, many rules are broken and innovations are made when it comes to drop shadows. You can even choose other colors for shadows, not just black or gray. Let's explore a variety of drop shadows that will help you render a more dimensional version of your brush lettering.

1. SINGLE LINE: Draw drop shadows with a regular marker or pen (fig. 1).

2. BRUSH LINE: Draw drop shadows with a brush pen; gray or black are commonly used (fig. 2).

3. MONOCHROMATIC: Draw drop shadows with the same color, but darker than the letter strokes (fig. 3).

4. PATTERNS: Draw elaborate drop shadows that have intricate designs (fig. 4).

Adding Highlights

A highlight would be the opposite of a shadow. Instead of creating depth with an illusion of the letter receding into the background, you are making the surface appear to be rising from the foreground.

Here are two ways to add highlights to make your letters more dimensional:

1. ADDING WHITE: By using a white marker or pen, draw lines on the interior spaces of the strokes. I usually put mine off-center to the left in the top half or more of the stroke (fig. 1).

2. PLAYING WITH THE EFFECTS OF ADDING A THICKER WHITE LINE TO MAKE THE LETTER SURFACES APPEAR ROUND OR CURVED: Depending on the white pen used, sometimes the color of the letters bleeds through the white and tints it lightly (fig. 2).

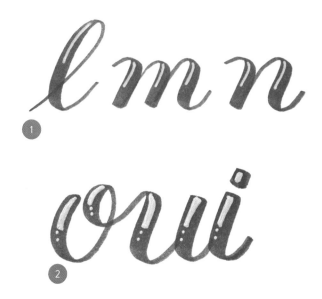

Outlining

The concept is deceivingly simple: Draw lines around your letters. However, the results can look less than stellar when the lines aren't smooth and fluid. Often, our most confident lines are drawn in a downward motion. When I draw outlines, I rotate and move the paper constantly to draw lines downward in a consistent manner. Following these guidelines will help you achieve perfect outlines.

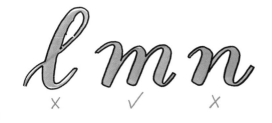

1. Find a smooth writing pen or marker that glides.

2. Use smooth paper.

3. Start and stop at natural break lines.

4. Turn or move your paper and hand.

5. Don't cross intersecting strokes. Remember, it's an outline.

Creating Thicker Downstrokes

The beauty of brush lettering lies in the contrast between thick downstrokes and thin upstrokes. Adding additional lines to thicken those downstrokes will give your letters and words an even bigger *wow* factor.

This quick technique is best achieved with a black brush pen. Simply write the word and then go back and draw more downstrokes beside the original ones.

Adding Patterns

Using other pens of any color, you can draw countless patterns on the interior spaces of the strokes and letters.

Simple stripes and polka dots can be a starting point, but you can design any kind of pattern in any color.

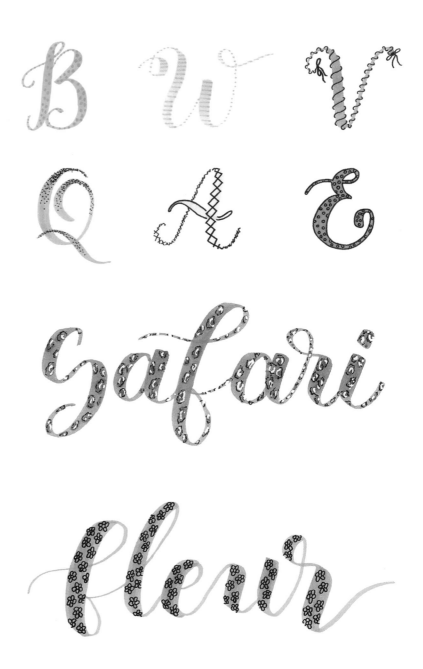

BLENDING

Using brush pens is an artistic endeavor, and designing colorful word art is a really fun way to express your creativity with brush lettering. Combining more than one color and blending them together is really easy. I do these techniques with water-based brush pens, and I often use smooth water-color paper because the layering of colors might cause regular paper to pill or tear.

One supply needed for this is a plastic palette, which can be as simple as a plastic bag or an actual plastic coated card. Tombow, for example, has a blending palette and blender brush pen specifically for this use. I recommend a white plastic palette to show the true colors of the pens you're laying down.

A number of brush pen manufacturers also have a colorless blender brush pen. These are very helpful when creating multi-colored letters by layering and blending. There are three blending special effects we explore: ombré letters, two-tone letters, and rainbow letters.

Ombré Letters

Ombré is the gradual blending of one color hue to another, usually moving from light to dark. When I create ombré brush letters, I start with dark at the top and lighten downward toward the baseline. To achieve this pretty effect in brush lettering, follow these simple steps.

1. Choose a single light color of brush pen and write your letters or word. Then with the *same* brush pen, add a second layer of color on the thick downstrokes about three-fourths of the way down (fig. 1).

2. Add a third brush stroke on the same stroke on the top fourth of the layers. Add a final covering brush stroke with the same pen or blending pen (fig. 2).

3. If you have a really steady hand, then layer color the same way on the thin upstrokes too. Be careful to stay within the edges of your original strokes.

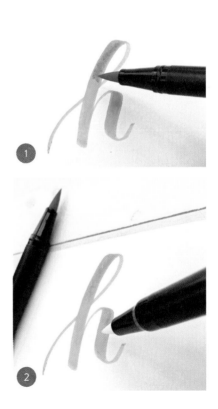

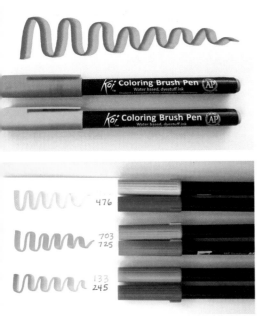

Two-Tone Letters

A basic way to blend colors is to choose two tones that work well together. This can be the same color family or not, whatever you find pleasing and blends well. It's time to explore and discover how your brush pen colors interact with each other. You'll quickly learn which colors play well together and which don't. It's helpful to make a swatch that's labeled with color combinations to keep on hand for future reference when blending.

1. Pick two pens, one color lighter than the other **(fig. 1)**.

2. Use your white plastic palette to make a swatch of the darker color. With the lighter of the two pens, pick up the darker color from the palette. Write your letters, pausing to pick up color when lifting between strokes. You can also continue to write letters without picking up more color and gradually the original pen color will appear **(fig. 2)**.

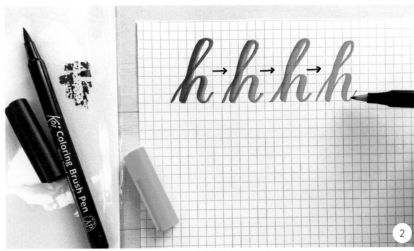

"CLEANING" BRUSH PENS AFTER MULTICOLOR LETTERING

Will your brush tips be contaminated or ruined by blending with another color? Not at all. The beauty of water-based brush pens is you can *clean* a pen by just scribbling out the added color on a scrap piece of paper until the true pen color remains.

Rainbow Letters

The water-based brush pens come in every color of the rainbow . . . and literally can be used to create a rainbow effect. By combining colors and blending them, you can make colorful, eye-catching projects.

For rainbow letters, you'll need brush pens in these colors: red, orange, yellow, green, blue, purple, and pink. You can alter these color choices. I substituted pink for indigo because sometimes blue, indigo, and violet are very similar, and the differences between them are too subtle to make an impact.

1. On your plastic palette, make swatches of all the pen colors except the last one (fig. 1).

2. Starting with your second pen color (in the example above, it's orange), pick up the first color (in this case, red) from your palette and begin to write your first strokes. Stop at a natural lifting point. You'll see the color change as you write with the one you picked up from the swatch to the original color in the pen you're holding (fig. 2).

3. Repeat step 2 with your third pen color (yellow), picking up some of the second color (orange) before starting your next letter (fig. 3).

4. Continue in this way with the rest of the colors to complete the rainbow sequence (fig. 4).

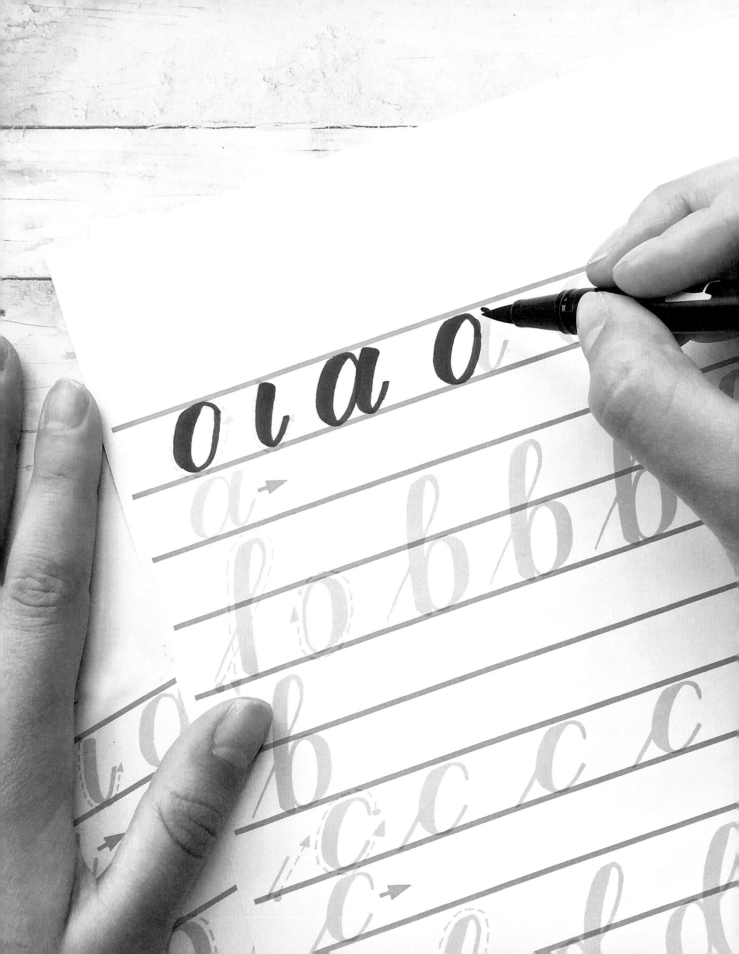

8

Exemplars and Tracing Worksheets

In the pages that follow are practice worksheets for both large-tip and small-tip brush pens. These tracing guides include both the uppercase and lowercase alphabets, numbers, and some punctuation. By tracing the light gray letterforms over and over, you'll build up your muscle memory and eventually leave the guides behind to write your own freestyle letters.

COMMONLY ASKED QUESTIONS

Is There a Specific Order?

Although these worksheets are ordered alphabetically from *a* to *z*, I highly recommend beginning with the basic strokes and drills from chapter 3 and then following the same progression as outlined in chapter 4. After you become proficient with writing the lowercase alphabet, proceed to the uppercase alphabet.

How Long Will It Take Me to Learn?

People often contact me and say they don't see much improvement . . . after only a week! When I was learning, I practiced daily for about four months before I felt confident about my skills. Everyone progresses at different rates, and even now my style and finesse are still evolving.

Can I Write in This Book?

The paper in this book is very smooth and suitable for your brush pens; however, I do recommend removing the pages and writing on a single sheet on a flat surface or using tracing paper on top. If you are photocopying the worksheets, use very smooth, heavyweight copy paper as outlined in chapter 2.

Why Does My Brush Tip Fray?

Even if you use smooth paper, your brush tips will break down eventually—but you can still use them. Just ignore the uneven lines created by the frayed tip and concentrate on your thick and thin strokes and transitions. Also, check the angle of your pen while you write to make sure you're applying pressure to the *side* of the brush tip.

Where Can I Find More Worksheets and Resources About Brush Lettering?

To help support you in your brush lettering practice, I encourage you to visit my website and blog: www.kellycreates.ca. You'll find tutorials, additional sets of tracing worksheets, and helpful tips in my monthly email newsletter "Kelly Letters." Feel free to email me your questions and follow me on social media. Sharing my love of letters is my passion, and together we can enjoy a peaceful, mindful practice of this beautiful art form.

a b c d e f

g h i j k l

m n o p q r

s t u v w x

y z

A B C D E

F G H I J

K L M N O

P Q R S T U

V W X Y Z

a a a a a a a
a→
b b b b b b
b→
c c c c c c
c→
d d d d d d
d→

| LOWERCASE h–j: LARGE BRUSH PENS

k k k k k k

l l l l l l l

m m m m m

n n n n n n

A A A

B B B

C C C

D D D

E E E

K K K K

L L L L

M M M M

N N N N

O O O O

PPP

QQQ

RRR

SSS

TTT

U U U

V V V

W W W

X X X

Y Y Y

| UPPERCASE Z AND PUNCTUATION: LARGE BRUSH PENS

000

111

222

333

444

5 5 5

6 6 6

7 7 7

8 8 8

9 9 9

a b c d e

f g h i j

k l m n o

p q r s t

u v w x y

z

A B C D E F

G H I J K L

M N O P Q R

S T U V W X

Y Z

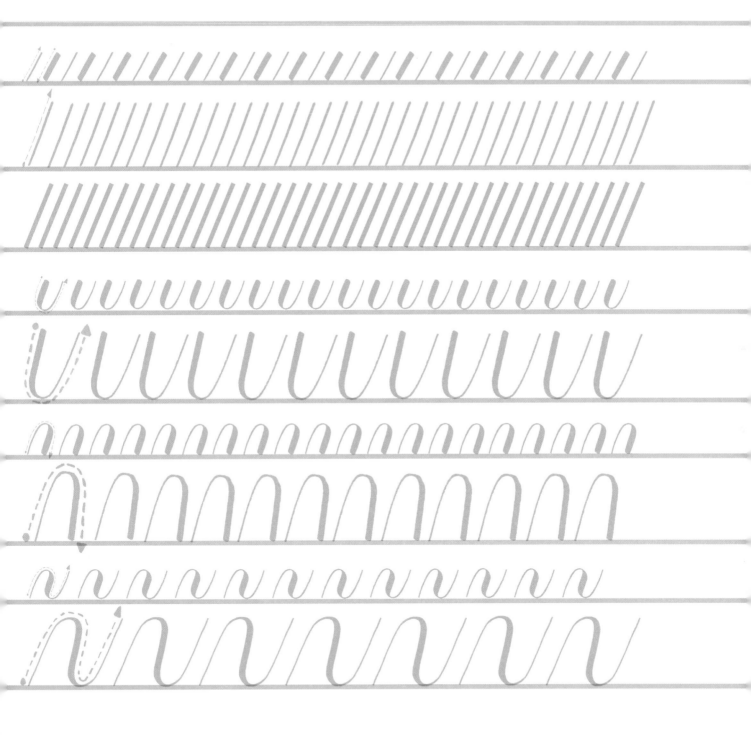

a a a a a a a a a a a a a a a

b b b b b b b

c c c c c c c c c

d d d d d d d d d

e e e e e e e e e e e e

f f f f f f f f f

g g g g g g g g

h h h h h h h

i i i i i i i i i i i i i

j j j j j j j j j j j

k k k k k k k k k k k

l l l l l l l l l l l l

m m m m m m m m m m

n n n n n n n n n n n

o o o o o o o o o o o o o

p p p p p p p p p p

q q q q q q q q q q q

r r r r r r r r r r r r r

s s s s s s s s s s s s s s

t t t t t t t t t t t t

u u u u u u u u u u u u

v v v v v v v v v v v

w w w w w w w w w

x x x x x x x x

y y y y y y y y

z z z z z z z

A A A A A A A A A A →

B B B B B B B B B →

C C C C C C C C C C C →

D D D D D D D D D D →

E E E E E E E E E E →

F F F F F F F F F F F →

G G G G G G G G →

H H H H H H H H H →

I I I I I I I I I I I I I →

J J J J J J J J J

K K K K K K K K

L L L L L L L L L

m m m m m m

n n n n n n n n

O O O O O O O O

P P P P P P P P

Q Q Q Q Q Q Q Q

R R R R R R R R

S S S S S S S S S S S S →

J J J J J J J J J J J J →

U U U U U U U U U U →

V V V V V V V V V →

W W W W W W W W →

X X X X X X X →

y y y y y y y →

z z z z z z z →

1 1 1 1 1 1 1 1 1 1

2 2 2 2 2 2 2 2 2 2

3 3 3 3 3 3 3 3 3 3

4 4 4 4 4 4 4 4 4 4

5 5 5 5 5 5 5 5 5 5

6 6 6 6 6 6 6 6 6 6

7 7 7 7 7 7 7 7 7 7

8 8 8 8 8 8 8 8 8 8

9 9 9 9 9 9 9 9 9 9

0 0 0 0 0 0 0 0 0 0

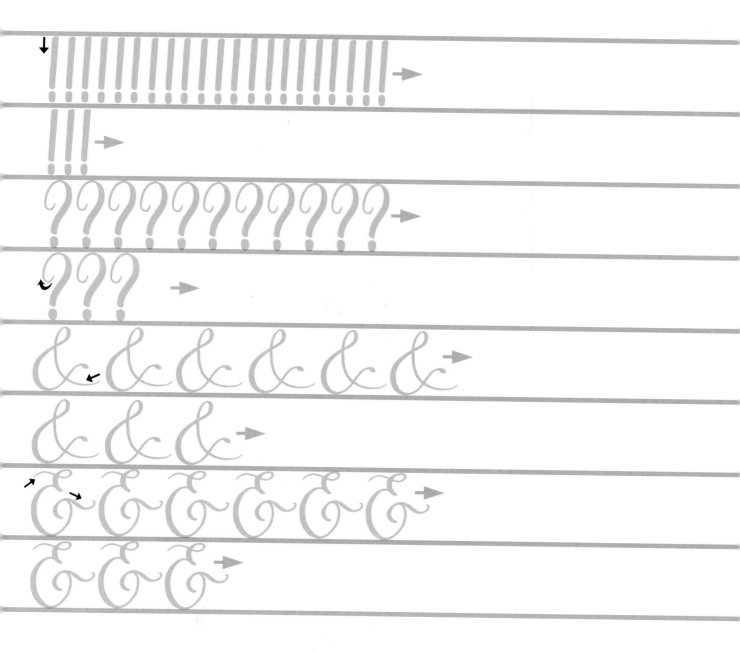

ACKNOWLEDGMENTS

I am deeply grateful for the support, encouragement, and love from my family. My parents and brother taught me the value of hard work, innovative thinking, and risk taking. Our family has a strong entrepreneurial spirit along with a generous philosophy of giving back to the community.

I am so blessed to have a husband and children who unconditionally love and accept me for who I am: a wife, a mother, a teacher, an artist. Without them cheering me on, I would not be studying calligraphy, teaching, or writing.

So many of my friends, too many to name, have uplifted me in countless ways, with helpful advice and kindness. They have motivated me to grow as a person and an artist and have enriched my life beyond measure. Special thanks to my hand model Taegan Lloyd.

I thank the countless teachers I have had over the years, who inspired me to creatively pursue my own path as an educator. Ever since I was a little girl, the desire to teach has always been an integral part of who I am.

Author photo by Madeline Ludlage Photography

I am lucky to be part of the Creative Scrapbooker team, crafty and artistic souls who eat, breathe, and sleep creativity. They watched me embark on my lettering journey and are always excited about my adventures in art. They are my tribe.

I would not be a lettering artist if I didn't have pens, and I am incredibly grateful to the companies that have sponsored workshops, providing excellent tools for my students and me: Tombow, Sakura, Kuretake, and Marvy Uchida.

The amazing journey of writing this book happened because of the wonderful editors at Quarry Books. Thank you, Joy, Meredith, Heather, Lisa, and everyone at The Quarto Group who were instrumental in making my dream become a reality.

I feel incredibly fortunate to share my love of art and calligraphy with others around the world, both online and in person. After presenting a workshop, I walk away with even more knowledge and creative energy and feel very thankful to spend time with people who love letters as much as I do.

ABOUT THE AUTHOR

Kelly Klapstein lives in northern Canada with her husband, three children, dog Finn, and a lot of pens. When not writing, she is painting with watercolor, crafting, and teaching brush lettering workshops around the world.

INDEX